"Through the lens of a young American woman visiting the Maasai culture, Joni Binder reveals how the unique struggles of one community and one culture are not separate from the common plight of humanity's women and girls. May this book be not only a wake-up call to the continued global violence against women and girls, but a call to action to all of us, to use our voices to challenge ideologies and practices that enable oppression to persist in all forms and across all cultures."

—Jennifer Siebel Newsom, documentary filmmaker and founder and CEO of The Representation Project

"With words of remarkable precision and images of stunning clarity and beauty—qualities that are all the more striking for the artist in her youth—Joni Binder documents her time among the Maasai in the late 1980s. What makes *Mile 46* such a revelation is the depth of its empathy, the calm intelligence and mature awareness that saturates every image. Neither a mere travelogue nor a wide-eyed record of faraway experience, the book is, instead, a brilliant and indelible work of art."

—Matthew Specktor, author and a founding editor of the *Los Angeles Review of Books*

"*Mile 46* is a sensitive account of a young woman's exploration of traditional Maasai life. Readers who take a chance on this book will be richly rewarded. Binder is a trusted guide who examines herself as closely as she examines the community around her. Elegant photographs accompany clear-eyed, compelling prose to create a reflective, heart-felt, and genuine portrait. Step off the beaten path and into this wonderful gem of a book."

—Natalie Baszile, author of *Queen Sugar*

"These lovely photographs describe the [author's] encounter with a traditional African family miles and miles away from contact with anything remotely familiar to her. They present a world now radically changed without sentimentality or exoticism. They are remarkable for their maturity, for their sensitive description of a way of life so different from her own experience and now so distant in time, and they reflect a kindness and sensitivity to her hosts, as interested in her as she was in them."

—Sandra Phillips, senior curator of photography, San Francisco Museum of Modern Art

"*Mile 46* is a fascinating and thoroughly engaging personal narrative that draws the reader in at every turn. So much of this culture was unknown to me—particularly the practices relating to women and girls, whereby it is so important to raise awareness and shed much needed light on a topic that continues to take center stage from a global perspective. Binder's photographs are stunning and often blur the boundaries between the written word and text to create a mesmerizing ensemble."

—Nina Ansary, author of *Jewels of Allah*

MILE 46

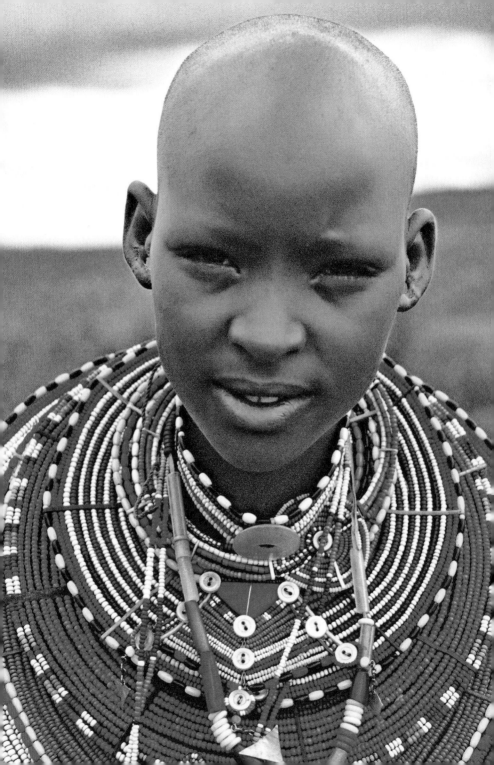

MILE 46

FACE TO FACE IN MAASAILAND

by Joni Binder

Foreword by Darius Himes
Photographs by Joni Binder

EARTH AWARE
EDITIONS
San Rafael, CA

From the past:

For my uncle Herb, who gave me
the camera I took with me to Kenya, and
For my father and my mother,
whose belief in me gave me my confidence.

In the present:

For my friend Christine Suppes,
who urged me to sit down and write, again, and
For my husband, Robert, for everything else.

To the future:

For my son, to make you proud, and
For my daughter, wherever you go, I am with you.

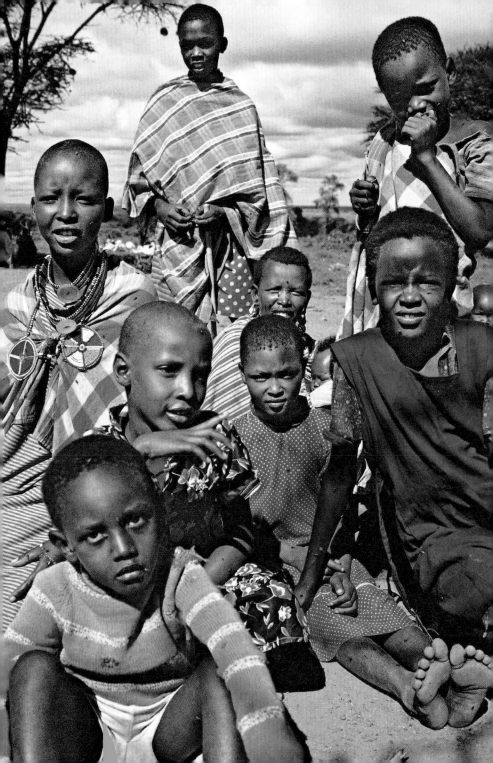

CONTENTS

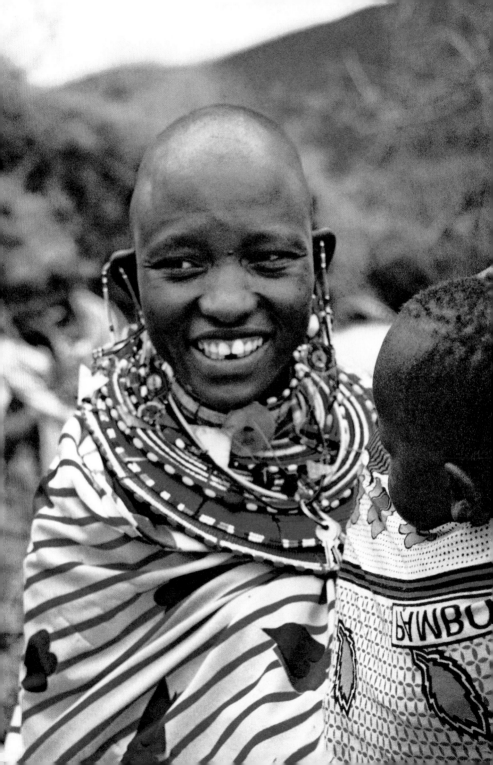

FOREWORD

The book before you is humble in origin and exists as a blend of memoir and critical essay. The contours of the originating experience are not unusual: A young woman—an American college student—spends a semester abroad in a completely foreign culture—in this case, in the region of Kenya known as Maasailand—and returns with a bag of exposed film and a stack of filled journals, forever changed by the people she has met, the lives and rituals she has witnessed, and the experiences she has gained.

And while that sounds common enough, Joni Binder's memoir is decidedly not a stereotypical story about "finding herself." This book is about the advancement of civilization and the moral and spiritual evolution of the human race, grand as that may sound.

This memoir overflows with the ideals of youth—they are pulled directly from Binder's journal pages for all to see, written in the script of a twenty-one-year-old and penned with a certain amount of naiveté. In the intervening decades, however, those ideals and her experiences in Africa have been digested and calibrated, and have worked their way into the motivating principles of a life devoted to social justice, to the positive role that the arts can play in society, and ultimately—to change.

What happened during that time in sub-Saharan Africa? Not surprisingly, Binder's youth was a time when the pursuit of "Truth" was central to her interests, when uncovering the organizing principles of an unjust social structure was what drove her studies, and when a desire to learn

Opposite: The Maasai's instinctive dislike of the camera and general distaste for non-Maasai culture belies their undeniable curiosity about both.

about her fellow humans, no matter where they reside, motivated her to abandon all comfort and familiarity in favor of knowledge gained through actual, lived experience.

In an act of sustained vulnerability, Binder offers us her journal entries of nearly thirty years ago: "My motives were unclear to them. Kimutai had not explained my presence to anyone. He just boasted about having an American girl in his home." A whole host of characters are introduced to us as she makes her way to Maasailand in 1988. What stands out is the mind of an inquisitive, spiritual, and ethically minded young woman, searching for . . . what? My sense is that she is searching for what I'll call a "foundational" identity. Divested of culture, class, religion, and even gender, who are we? That is her question. Is there an identity that all humans share and that exists outside of "time and place"? Can one find that "thing," identify that reality, even when the "costume" of a culturally specific identity—in this case late-twentieth-century-Maasai—is staring you in the face?

Her unassailable answer is "Yes."

The principle of the oneness of humanity, which Binder wrestles with throughout her journals, touches on a chord in the deepest reaches of the human spirit. This principle is not simply the idea of sisterhood or political solidarity, and it is definitely not merely a vague hope or notion. It embodies a larger reality that could be called an eternal spiritual or moral truth brought into sharp relief during the twentieth century, as the world's borders have become more and more porous.[1]

As an example, the UN's Universal Declaration of Human Rights is a relatively modern and very bold endeavour to verbalize that truth, and it's definitely not the first attempt:

> All human beings are born free and equal in dignity and rights. They are endowed with reason and conscience and should act towards one another in a spirit of brotherhood. Everyone is entitled to all the rights and freedoms set forth in this Declaration, without distinction of any kind, such as race, colour, sex,

language, religion, political or other opinion, national or social origin, property, birth or other status. Furthermore, no distinction shall be made on the basis of the political, jurisdictional or international status of the country or territory to which a person belongs, whether it be independent, trust, non-self-governing or under any other limitation of sovereignty. . . . No one shall be subjected to torture or to cruel, inhuman or degrading treatment or punishment. . . . Everyone is entitled to a social and international order in which the rights and freedoms set forth in this Declaration can be fully realized.[2]

Binder was not engaged in a form of cultural tourism; there are much more pleasant places to do that. Nor was she there searching for a "wild African lover," as she outlines in one section of her journals, a stereotype that had been played out for decades in Kenya (and, without a doubt, around the world).

What her photographs delineate is a world far outside of her narrow scope of experiences. Frame after frame, she pointed her camera at the individuals she encountered, recording the buzz of rural life with the innocence of a first-time visitor. The clothing, food, gestures, and shelters are all different. The smiles, however, are not.

Beyond simply observing and describing her surroundings, Binder began to make value judgments about the nature of the human relationships that she witnessed in this one Maasai family in 1988. And even then, she was conscious of the pitfalls of such thinking.

One has to be careful when discussing culture. Walking the line between observation and judgment is a challenge for anyone who is aware that there is a difference. . . . Every American family is different—I think the same can be said for the Maasai. This book is a snapshot of a Maasai family that took me in in 1988. . . . Being a part of some movement I imagined I would

put an end to female circumcision. How could I, who had never been to a country where it was practiced, begin to understand its cultural significance? Who did I think I was to presume to put a stop to a practice that was both historic and sacred?

Binder's concerns, however, are the ones that define our age, an age in which humanity struggles to adapt to the needs and responsibilities that come with what can only be described as social maturity. As a single human race, we have made unimaginable advances since the Industrial Revolution, advances that have put the farthest reaches of the planet, and the people who inhabit those locales, within reach and scrutiny of all other cultures. It is hardly necessary to point out the fact that 150 years ago the world was devoid of what we—particularly those of us in the industrialized West—consider the most basic amenities, such as electricity, running water, access to food, and functioning transportation and sewage systems, let alone access to the knowledge of how others live and think and believe.

One of the most fundamental issues that presented itself to Binder during her semester abroad was the role and social position of women and young girls. Many outstanding advocates for women's rights have written on the cycle of misinformation and lack of education experienced by many women around the world. Destructive customs are passed down generation after generation, obstructing the kind of social progress that should be available to women. Respect plays a central role, particularly in the home. The fundamental equality of women and men—not to be mistaken for sameness—is undeniable. When the vast inequalities that are prevalent in the world are perpetuated—even in the industrialized and educated West—it is an inexcusable injustice against one half of the world's population. As was noted during the UN World Conference on Women in 1995, this attitude in turn "promotes in men harmful attitudes and habits that are carried from the family to the work place, to political life, and ultimately to international relations. The world can ill afford the consequences of such ignorance and injustice, especially at this critical moment when prospects for establishing peace on this planet are bright."[3]

As important as the ramifications of our material advances are, they cannot be considered without first acknowledging the lack of advances in our moral and spiritual postures in relation to, well, everything. The advancement of civilization on this planet cannot truly happen unless we as a species collectively see spiritual and material aspects of situations as wings of one great bird about to take flight. One wing cannot create flight if the other wing is broken or atrophied.

This is as ancient a quest as we have in recorded history, and it is as paramount for us individually and collectively now as it ever was. Joni Binder's guidance on this journey is a rare combination of heart and mind: kindheartedness coupled with a desire to investigate truth and reality, knowledge over opinion.

—Darius Himes, Christie's International Head of Photographs

New York City, October 2015

NOTES

1. Baha'i International Community, "One Same Substance: Consciously Creating a Global Culture of Unity." Submitted to the World Conference Against Racism, Racial Discrimination, Xenophobia and Related Intolerance, Durban, South Africa, August 31, 2001. https://www.bic.org/statements/one-same-substance-consciously-creating-global-culture-unity.

2. *The Universal Declaration of Human Rights*, Articles 1, 2, 5, and 28. Adopted by the UN General Assembly on December 10, 1948. http://www.un.org/en/documents/udhr.

3. Baha'i International Community, "The Greatness Which Might Be Theirs." Reflections on the Agenda and Platform for Action for the United Nations Fourth World Conference on Women: Equality, Development and Peace, Beijing, China, August 26, 1995. https://www.bic.org/statements/greatness-which-might-be-theirs-girl-child-critical-concern.

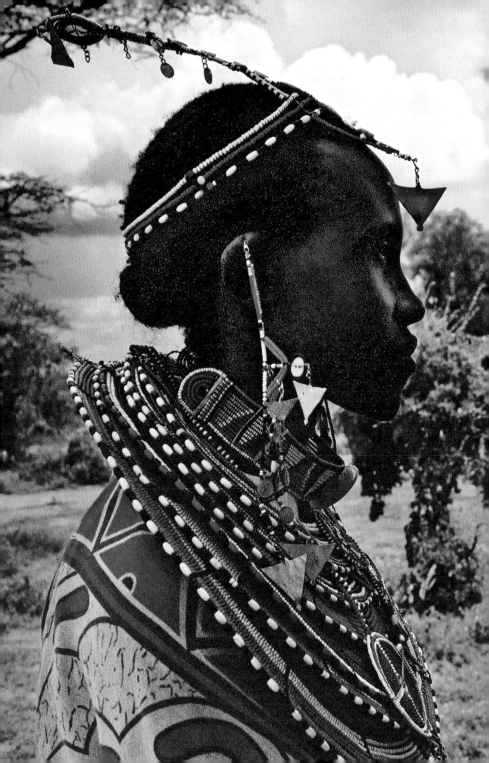

PREFACE

Twenty-five years ago, I took a semester off from school and enrolled in an exchange program at a coffee-plantation-cum-college campus in Katheka -Kai, Kenya, in the heart of the Kamba tribal territories. My hosts during this five-month stay in Kenya were everyday people: coffee-farming Kambas, Muslim Swahili islanders, and small business owners in and around Nairobi and Mombasa. I was exposed to diverse and interesting cultures during my time in Kenya, but I ultimately fell in love with the dramatic presence of the Maasai and found a way to live with a Maasai family. They resided on the very borders of Nowhere: There was no name for where I was; no village, just a small homestead of six adults, twenty kids, and about fifty head of cattle. The best way to define our location was by referring to a mile marker staked in the ground and painted with "Mile 46," which was about an hour's walk from the dung hut where I lived. Had the homestead been closer to the railroad, it would have been forty-six miles from Nairobi on the tracks that led to Mombasa.

People lucky enough to spend a vacation or go on a safari in Kenya or Tanzania will have seen the show put on for tourists in the Maasai Mara National Reserve: warriors chanting and jumping in circles, women and girls adorned with layer upon layer of intricate beadwork jewelry in primary colors, men and women with their heads shaved and wearing layers of what looks like Scottish tartan. The Maasai in the Mara mug for the camera and ask for a "donation," then go home to old, worn-soft *shukas* and fold up their formal wear for the next business day. Even if one were just visiting Nairobi and not looking specifically for the Maasai, their traditional attire is an arresting sight in a sea of men and women in business wear

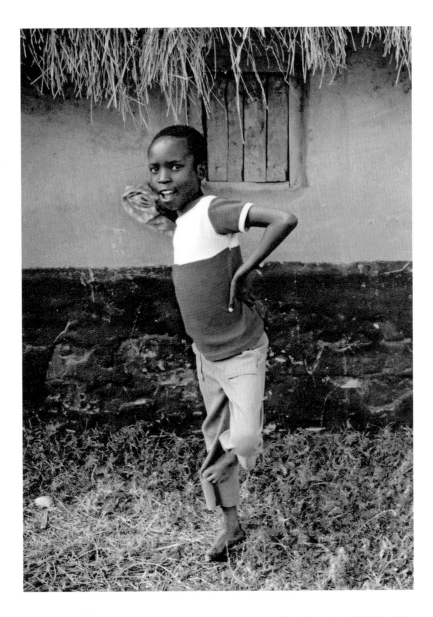

Above: A young Kamba boy mugs for the camera on the coffee plantation in Katheka-Kai.
Opposite: Mothers and their young children spend their hours outside in fair weather,
but there is not much to do besides enjoy each other's company.
Page 16: Sintamei poses in profile for a portrait.

and tourists in shorts and fanny packs, passports snug in nylon pouches dangling from their necks.

My experience with the Maasai was not staged for tourists. Not every day in Maasailand called for beads, spears, and dancing. Days that included dancing and ceremony were the special days that also called for feasting on plates full of fire-roasted meat and sipping from chipped mugs full of warm beer topped not by foam, but by dead bees, a strange but welcome change from days of drinking just smoke-tinged milk. The regular days had long stretches of hours with only fly-swatting, baby-minding, and conversation for activity. And during the night, after the fire went out, there was always the threat of a lion attack, but the real danger wasn't the lions—it was the aching restlessness and isolation of the undereducated and impoverished.

I kept journals while I was in Kenya in 1988 and returned to the United States with their tattered, Third-World-thin pages filled with scrawls detailing my experiences in vivid and sometimes graphic detail. I also came home with rolls of undeveloped slide film. When I was back in California, I began to review my images and my words and, with the

benefit of distance, began to record other memories that I did not write about while abroad.

What I witnessed and documented at twenty-one reads and looks different to me today, a quarter of a century later. Today I'm more attuned to the effects of the Maasai's entrenched cultural practices that include polygamy, statutory rape, and female circumcision. I am more aware of my naïveté at that age, and I see the circumstances into which I put myself very differently. I am now the mother of two inspiring, beautiful, and challenging teenagers: an innocent, sweet son with Asperger's Syndrome and a bold, bright, artistic daughter. I think of her most of all when I imagine myself as a young woman telling my parents that I was going to Kenya. Rereading these journals now and rediscovering the contemporaneous photos is like bending time. I am grateful for a twenty-one-year-old who

Above: Tea playing dress-up, posing with the children of Kimutai's boma.

kept journals and took photos. I am grateful that my parents did not object to my plans, though I cannot imagine how or why they didn't. Sending their only daughter to a place a world away, a place without telephones, roads, electricity, running water, or GPS . . . it seems reckless to me today.

And despite the fact that the program I went with had been established in Kenya for some years, I'm sure it seemed somewhat reckless to my parents at the time, too. But by the time I went to them with the program brochure, in my head I wasn't bringing a discussion or request—I was providing notification. I asked my father recently what he thought at the time of our conversation. He put it succinctly: What could I have done to stop you?

I am much more at ease with myself, less impulsive and more steady, with the throes of my twenties long behind me. Since 1988, Africa has advanced in certain ways, and so have I.

While time has granted me stability, it has not been as generous with Africa. Today many new, dangerous influences have ignited because of war, drought, poverty, terrorism, and religious fundamentalism. It was inspiring and important to see the world's response to the nearly three hundred high school girls in Nigeria who were kidnapped by the terrorist organization Boko Haram to be used as political bargaining chips and sold into slavery or marriage—but it's still an atrocity that anything like that can happen at all in today's world.

Fifteen out of the top twenty countries that engage in arranged marriages of young girls—often a euphemism for slavery—are in Africa. Young girls forcibly "married" to much older men are almost always destined for abuse and violence. This situation puts girls at risk for HIV/AIDS and denies them an education and any chance at prospering. There is no opportunity for these girls to escape poverty or indignity, and they very rarely, if ever, have a chance to determine the outcome of their own lives.

Because of expanding media exposure, Africa probably means something altogether different to a twenty-one-year-old today than it did to me then. It might mean "safari" or "genocide"; it might mean "emerging markets" or "refugees," "lost boys" or "Somali pirates." Today's media stories of

the region's tribal warfare, acts of terror, and denial of fundamental human rights echo too resoundingly and too repetitively from many parts of the continent for the rest of the world to ignore. There is so much beauty to behold in Africa, and sometimes those images are communicated, but too often we are exposed to only the most gruesome, sensationalistic images and terrifying tales.

However, Africa does not represent only one culture, and it certainly doesn't only harbor violence and transgressions. It is a continent rich with incredible diversity, opportunity, range, and beauty. It is a complex, massive geographical expanse with thousands of ethnicities, languages, landscapes, and traditions. It is where heartbreak and inspiration coexist, where oceans meet deserts, and where many people live with an immediate relationship to their natural surroundings, and their lives often reflect the simple beauty of that.

I pored over books about Africa as a child and young adult. I broke the binding of Peter Matthiessen and Eliot Porter's *The Tree Where Man Was Born / The African Experience* and later obsessed over Angela Fisher's *Africa Adorned*. These books stirred a passion for Africa in me and gave me a rough sketch of what I might find when I finally arrived. I knew it would not look like home. I knew there would be people who ornamented themselves in fantastical, mystical, colorful ways; I knew there would be wild animals of all kinds roaming the landscape. Other books encouraged different expectations: Hemingway's *Green Hills of Africa* will stoke the fires of romantic feelings about East Africa in perpetuity but mostly in a way that stirs male fantasy. The more resonant storytelling for me is the writing of Karen Blixen, who wrote *Out of Africa* under her nom de plume, Isek Dinesen. Both Hemingway and Blixen wrote from actual experiences derived from their time in East Africa. Blixen wrote about her adventures and fell in love with the culture of the Kikuyu in Kenya. I read her book and imagined my adventures and my own cultural connections there, too.

One has to be careful when discussing culture. Walking the line between observation and judgment is a challenge for anyone who is aware that there is a difference. It is not always easy to look at new things and swallow

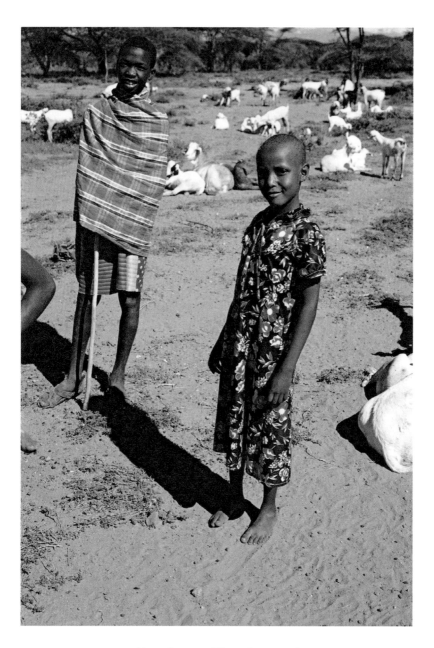

Above: Santamo, Kimutai's son, and
Naserian's middle daughter.

them whole—with age and education, we begin categorizing and imparting judgment on all we see. At twenty-one years old, my perspective was in development, and I daresay my heart was open. I understood that my viewpoint was entirely subjective. I was also very fortunate to be able to indulge my youthful impulsivity with manageable consequences. I understood that by being in Kenya I would change and that I would change the lives of those I encountered.

Like Hemingway and Blixen, what I witnessed firsthand doesn't make me any sort of authority of anything beyond my own experiences. I knew the people I knew and only saw what I saw. Every American family is different—I think the same can be said for the Maasai. This book is a snapshot of a Maasai family that took me in in 1988, and all of the things I wrote really happened around me or to me. These events affected me then—they helped shaped me into who I am now, and they deepened my convictions.

While enrolled in the Friends World College exchange program, which allowed me to study and live in Kenya, we students spent time with professors from the University of Nairobi. One lecture we had at the university was titled "Women in Kenya." Among many other things, we discussed the state of education, health, nutrition, and employment of women in Kenya in 1988. We learned that, because of the traditions of patrilineal inheritance, most Kenyan parents didn't feel that investing in a daughter's education was a good bet, whereas a son's education would probably pay off. In the northeastern provinces, most communities didn't believe women should receive any schooling at all. Why? Because they believed that girls would eventually become pregnant, and the education would go to waste. Not only was a girl's education inconsistent with traditional beliefs in many communities, but, in 1988, the popular thinking was that school-meted discipline was inferior to the discipline that would be dispensed at home—and that females needed strict discipline. Even outside of the northeastern region and throughout the rest of Kenya, the school

Opposite: Maasai woman prepares for the emuratare, holding a mat made from cowhide.

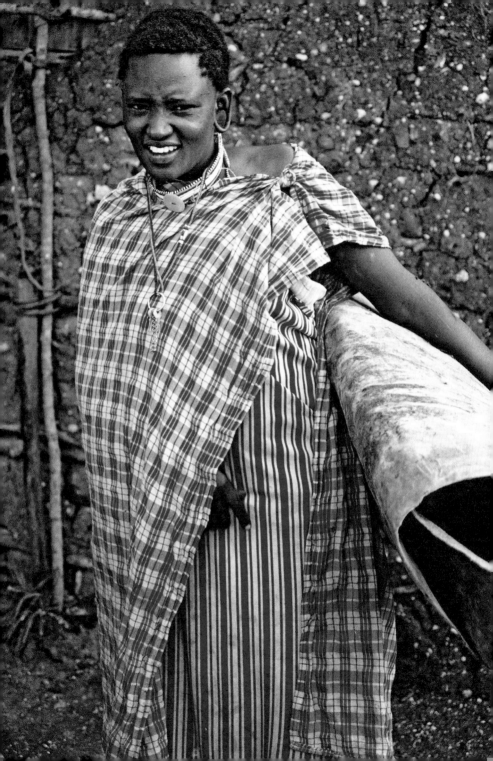

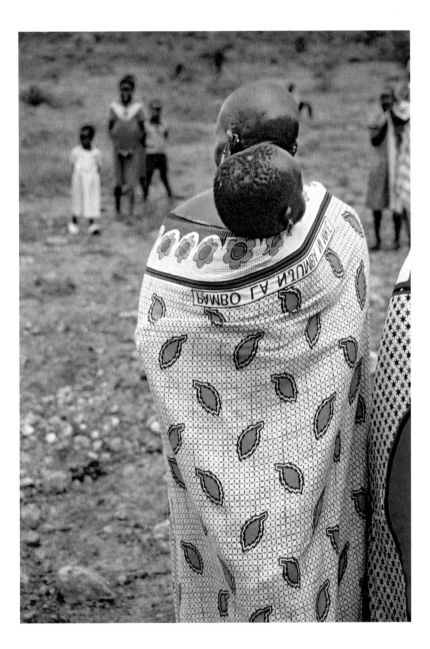

Above: Babies—and toddlers—rarely cry. They are almost always in the arms or on the backs of their mothers.

dropout rate for women was higher and academic performance was lower. Girls lacked parental encouragement and had domestic duties; all of this added up to an enormous, if not insurmountable, obstacle for girls trying to find their way into a classroom. Things do change, however: By 2003, all children, male and female, were entitled to a free education through a public system, though not every family takes advantage of the opportunity.

Women in Kenya, then and now, have little in the way of good fortune. According to the website of the Foundation for Sustainable Development (FSD), women in Kenya today are educated "at an inferior rate to their counterparts, increasing their reliance upon men. They are also limited from owning, acquiring, and controlling property throughout Kenya, regardless of social class, religion, or ethnic group. If women attempt to assert property rights over men or in-laws, they are often ostracized by their families and communities. This practice of disinheritance seems to be on the rise, particularly in areas hit hard by poverty." FSD also notes that "women's rights abuses continue to be practiced throughout the country. Examples include wife inheritance, widows 'inherited' by male relatives of the deceased husband; and ritual cleansing, the requirement of sex with a man of low social standing to 'cleanse' a widow of her dead husband's 'evil spirits.' These cultural practices maintain low self-esteem for women while completely ignoring the threat of HIV." The FSD report covers all of the different ethnic groups of Kenya without being specific about which tribes practice which traditions.

My journals from 1988 speak only to the Maasai and, more specifically, to the Maasai family with whom I lived. My heart broke for the contradictory beauty and suffering near Mile 46. The exquisite landscape, the generosity of my hosts, and their inclusive attitude were in contrast to dire conditions, ignorance, and suspicion. My observations are of a culture that has potent visual allure, that is mysterious, and that is both a world away and a type of reflection of all other cultures as well. We all come from places that are both beautiful and imperfect.

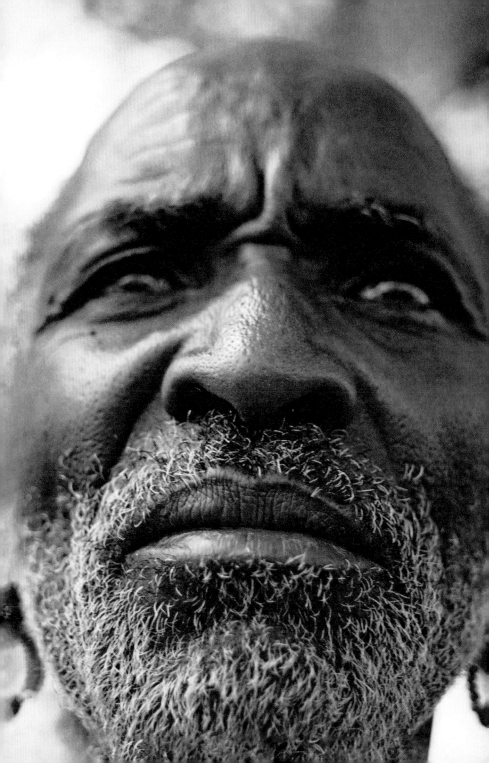

PROLOGUE

I am twenty-one years old. I have traveled over three continents to be where I am now, preparing to live with the Maasai. This was not my original plan. I'm winging it—not for the first time. I have my camera, empty journals, a couple T-shirts, a pair of old flip-flops, and a bottle of red hair dye.

To learn more about the Maasai, I spent this past weekend with Mama Simu, the Maasai woman the school has an arrangement with. Sinewy *lloimon*, or news carriers, came by earlier with a marriage proposal for Naisiae, an eighteen-year-old girl with a six-month-old baby who lives in this homestead. They also brought new calabashes for milking Mama's goats. Mama Simu beads tourist necklaces and works a scheme of filling water bottles with her garden hose to take advantage of never-the-wiser foreign visitors wisely cautioned against drinking untreated Kenyan water.

After the weekend, I got on the *matatu*, a small truck transport, back to Machakos so I could re-pack my things and prepare for my next trip. Mama Simu, me, and at least twenty others are squeezed into—and onto—a truck that would reasonably seat eight passengers. There are men on the roof, crammed together with chickens and baskets of cabbage and piles of old rags. They're all clamoring for a foothold or fingerhold because they know this is going to be a bumpy ride. More passengers mean more fares for the driver, so there is a compact of sorts: If you can fit, you can ride. There is no talk of risks or evidence of regulations.

I haven't showered in over a week. I've been sleeping on the dirt so my neck hurts, and I smell smoky from the always-lit fire of Mama Simu's hut. But I smell exactly like everyone else—or at least I think I do. Besides my odor, the rest of me would never pass for Maasai, regardless of skin color.

I have lived my life on grains instead of protein, and it shows. I am not sinewy. I am decidedly sturdy and Western, built more like *The Gleaners* from Millet's painting than the Maasai, who are 100 percent Giocometti.

I would like to sit down for this long ride, but the matatu is full, and I am foreign, and no one is going to make room for me. I still can't get myself to push others to make way for myself, so I end up with my bum hanging out of the side opening where a door would be, my head inside, my hand on a railing, and my toes in my too-thin flip-flops barely holding purchase on the doorjamb. Once the vehicle is so jammed it couldn't hold another chicken, off we go, bouncing and bumping along the muddy crevasses and rocks that constitute the road.

This weekend I'd held my own with Mama Simu. I wasn't skulking under a tree, simpering and self-pitying. I was a part of the conversation, I was useful, and I was a quick study with the beadwork. But now my spine is hitting the doorjamb over and over, and I am on the brink of tears, but I will *not* cry. I will not because if I do this whole illusion will shatter, and my good representation of a non-Maasai will be blown to pieces because I will be weak in Mama Simu's and the other matatu passengers' eyes. If I show weakness, I will be a living manifestation of the Maasai core belief that they are God's chosen people and that all non-Maasai are weak and inferior, not worthy of owning cattle or, most days, of receiving their attention.

But this is pain, not self-pity, damn it. The skin on my spine is surely splitting from the repeated hits. I breathe in and out, focusing on the fact that I will not cry. But they're all watching me now, sensing my weakness. Their glares crush my resolve more profoundly and painfully than the doorjamb crushes the bones in my back.

I know we're almost there, I know the consequences of any tears, but the stares and the spinal strikes are mounting and I am losing my resolve. And whether it was because I am near tears or because her head keeps hitting my knuckles and it is pissing her off, a woman grabs my hand and throws it off the railing and I begin to fall, ass-first, out of the moving matatu. Some arms from the tangle of men on the roof reach out and catch me and shove me back inside the matatu, and the motion cracks my head

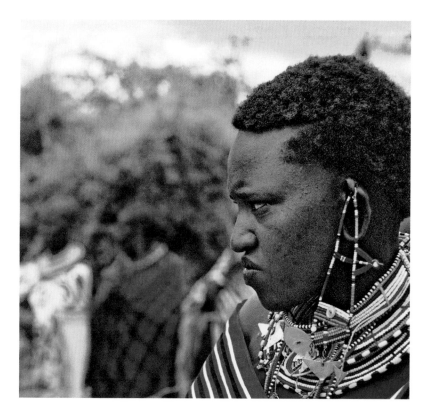

on the rim. A tear springs loose from my eye, and, like water finding its way through the earth, more tears soon follow, creating dirt-streaked pathways of shame on my face. The matatu smells like contempt, and the tongues are clicking and it is awful, awful.

When we get to Ngong, the ladies push me out of the door and onto the red dirt. Then they all push past me, trampling my belongings and fingers. Mama Simu doesn't look back. She doesn't even say goodbye.

Above: There's no room for weakness in the harsh conditions of the Mara.
Page 28: This elder Maasai warrior was photographed with the camera lens just centimeters from his face.

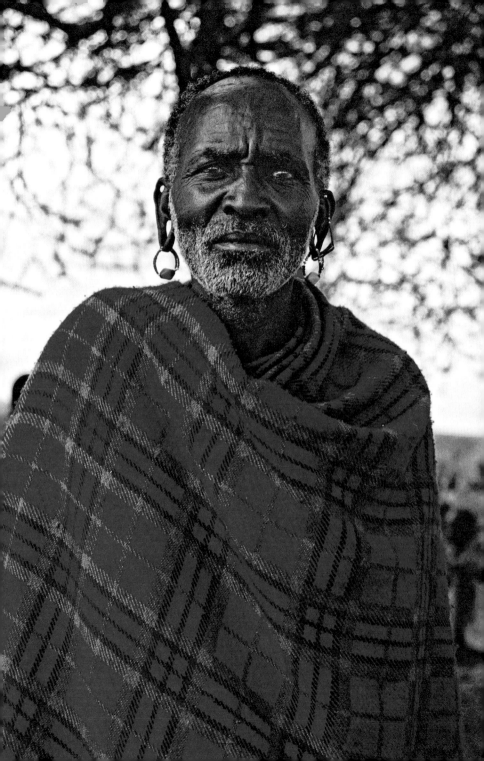

1

THE BEGINNING

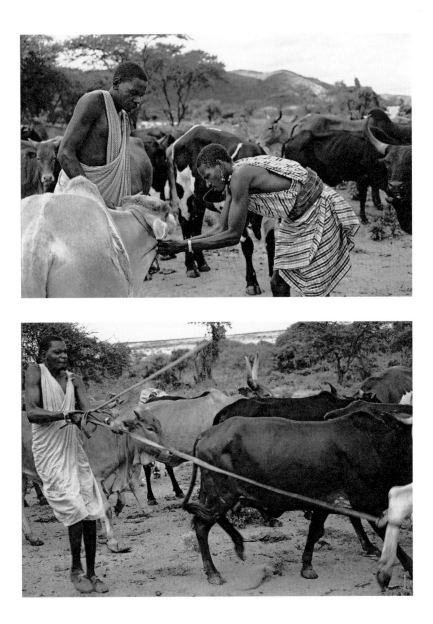

Top and above: In the morning, the first sound one hears in Maasailand
is the cowbells, the second is the moos. The cowbells don't stop until
sundown, but the mooing subsides once the cows are relieved of their milk.
Page 32: Blue-eyed Maasai elder warrior.

My semester abroad came about after two years at Columbia University and just a year-and-a-half at California Institute of the Arts (CalArts). I had left my Ivy League slot in favor of a spot at the radical, wildly creative, and artistically rigorous art school in the same quick, sharp turn that would inform my decision to go to Kenya.

At Columbia, my freshman-year roommate was from the South. She wore stockings and skirt suits with heels to class every day. In 1984, her type of femininity was contradictory and confusing to me. I had come from Venice, California, and had grown up surrounded by artists, iconoclasts, surfers, dreamers, and mellow intellectualists. I wore flowy skirts, combat boots, and thermals. I dyed my hair burgundy, then bleached it an awful platinum white that oxidized to a brassy orange, and shaved the sides of my hair off into a baby mohawk. I had a nose ring and too many holes in my ears to count.

I left Columbia after completing the Core Curriculum because there was no major there that would have satisfied my specific creative interests. I returned to California, where I enrolled at California Institute of the Arts. CalArts was and is a campus full of individuals deeply committed to their creative lives, and the culture is one of self-aware oddballs, eccentrics, geniuses, visionaries, and uniquely beautiful and creative men and women. I finally felt at home. I was studying photography, a passion I had discovered in high school. I took advantage of the cross-disciplinary ethos of the school and took classes in theater, video, and dance; I studied the tabla, a North Indian drum, and Irish finger drumming. But the class I fell hardest for was African Music and Dance.

The African Ensemble, the drum troupe at CalArts, was loud, and the pulse it emitted was—and still is—the heartbeat of the school. I could hear it from everywhere: the sublevel where the darkrooms are, the main gallery, the student café. African drumming makes a percussive, thrumming vibration, and one cannot help but be drawn to it. It's as close to a unifying principle for CalArts as exists there among the variety of unique artists of every discipline from every corner of the world. It's nearly impossible not to dance when the full ensemble performs.

"You. You always stand there, not inside, not outside. Come inside," a teacher of the class said one day as I was hovering on the threshold, listening.

And I did. I went in and never left. I joined the ensemble, I danced, and I was a founding member of the Women's Ensemble. I reveled in the environment, found a home in the music and with the teachers and students. I was in thrall with the sounds of the ensemble and the feeling of being a part of their creation.

In November 1987, just three semesters into my time at CalArts and after just two semesters in the African Ensemble, I was driving in an alley near my mother's house when an unlicensed Canadian girl put her cousin's car into reverse without looking and plowed backwards right into my car. Her father ran out of the back of the house with his arms waving, begging me to not call the police. He said he would pay for the damage to my car and that I could easily find him as I knew the address where they were staying. I shrugged and agreed. He asked me to get estimates for the repair of my car, and I got him two. One was considerably higher than the other. I don't know if it was guilt or gratitude, but he wrote me a check for the higher of the two and I took it—right to the lower priced auto body shop.

The difference gave me enough cash to make my way to Africa. This was not well thought out or considered, but I could vaguely imagine the photographic opportunities and the cultural value I'd find there. I found a reading room at UCLA where they had shelves of catalogs for foreign exchange programs, but most of the enrollment dates for the programs in Africa had already passed. The one exception was Friends World College, and their program was in Kenya—across the continent from Ghana, where my teachers at CalArts were from, but in the region of Africa I had read about growing up.

I applied and was accepted. I wasn't able to convince CalArts that any of my areas of study in Kenya would be applicable to my degree, so we agreed that I would take the semester off. In January 1988, just two months after the collision in a Los Angeles alley, I was scheduled to board a plane to New York for a weeklong orientation to prepare for my semester in Kenya.

In the time I had to prepare for my travels, I arranged to meet a couple of kids for lunch. They had recently returned from their semester in Kenya with the same program I had signed up with. I had done some reading on Kenya in preparation for my trip, and I think that's where I first heard of female genital cutting. When I met the students, a young man and a young woman, I was surprised by his response when I expressed enthusiasm for being a part of some movement I imagined would put an end to female circumcision. How could I, who had never been to a country where it was practiced, begin to understand its cultural significance? Who did I think I was to presume to put a stop to a practice that was both historic and sacred? He strongly recommended keeping my opinions to myself. I don't remember the young woman saying anything at all.

His words had an impact on me, and they overshadowed every other element of our conversation from that lunch—to this day, those comments are all I recall. At the time, his words made me unsure about having an opinion on female genital mutilation, yet I still reacted viscerally to the idea. One doesn't have to experience hunger to have a humanistic grasp on its devastating effects. And who does not empathetically respond to seeing someone else being kicked in the gut? We know what hurts, and we can connect to pain through our brain's capacity to imagine.

I began my trip soon after that lunch. The Friends World College program (now in a new home and with a new name: LIU Global) required a preparatory educational interlude in New York. I met my fellow students all ready to depart to destinations around the globe: Some were off to Costa Rica, some to Tokyo, still others to London and Paris. The small group going to Africa was comprised mostly of kids from Brown University who already knew each other: two were pre-med, one was an ornithologist, and one was an Africana Studies major.

Our small group traveled together to Kenya and spent time in regions all over the country. In addition to living on the coffee-plantation campus in Katheka-Kai near Machakos in the Kamba territories, we also lived on the island Lamu, home of the Swahili people. There we learned Kiswahili (which, along with English, is the official language of Kenya) and studied

Islam, Swahili culture, and how to construct a *dhow*, a lateen-sail boat. One of our teachers took us on a *dhow* overnight to some godforsaken unnamed island for a campout, but when the sun went down, a blanket of mosquitos descended upon us in a thick layer of black buzzing that forced us to hastily get back on the boat and set sail for quieter, less infested ground. We were assigned families on Lamu to spend our days with, and my hosts invited me to a Swahili wedding and taught me how to prepare some wonderful food. With our language skills honed by constant use, we students later went to Malindi, Mombasa, and Nairobi—all the while studying different aspects of Kenya by immersing ourselves in the day-to-day life of each region.

After four months of the school's planned curriculum, we were free to go on an independent study. I was a photography major getting no credit for my semester abroad and so was able to pursue whatever caught my eye. Having spent a month during the planned curriculum on Lamu with the Swahili people and participating in various ceremonies, including a traditional, gender-segregated wedding, I wanted to continue focusing my lens on rituals and the people who practiced them.

During my travels throughout Kenya, I fell in love with the striking silhouette of the Maasai: their shaved heads, their red plaid shukas, their posture, and the way that they kept to themselves. They were mystery and aesthetic, tradition and pride. I wanted to find a way to spend time with a family that still lived a traditional lifestyle. My Swahili teacher, Erastus, was Maasai, and in our many conversations he had expressed a seesawing and unresolved personal perspective about how he now wore buttoned shirts and pants to work instead of a red shuka and how he spent his days indoors, most often with foreigners, instead of outside with cattle and those who would have been his warrior brothers. I am sure he was flattered by my interest in his culture, and luckily for me he was sensitive to how

Opposite: Erastus, the author's Swahili instructor. He was Maasai, but lived in Nairobi and did not embrace the traditional lifestyle; however, he generously made arrangements for the author to spend time with Kimutai's family.

dramatic a change it would be for a young Western woman to suddenly be living in a *boma*, the traditional Maasai familial homestead comprised of a circle of dung huts. I relied on him to make the necessary discernments: With whom should I live? Where would I be safe? And how could he convince the school director that sending me there would not put me in any danger, as I would be completely out of contact with the school?

Erastus knew a butcher in Nairobi whose family lived a traditional life in a boma while he spent weekdays in the city and visited his family home on the weekends. The butcher was a prominent figure in the Maasai community in Nairobi, a robust and successful man who had lived abroad in Europe for a time and whom, Erastus felt, might be a good fit for me. After introducing us in a bar, arrangements were made, and I finally had plans to spend my independent study living with a Maasai family with the intention of photographing them both in their daily life and during their ritual ceremonies.

I didn't go to Kenya in pursuit of unlocking any Maasai mysteries or to announce myself as a citizen anthropologist. In fact, I only went to Kenya because Friends World College had a spot in its program there. I had a voracious curiosity, a hunger for experience, and unchecked determination. I had decided I wanted to go to Africa—remote, altogether different in its terrain and rhythms, and a million miles from family and friends—and, in a way that was naively indiscriminate and considered only with respect to the timing and circumstances of my car accident, I wasn't picky about where I landed. I had grown up in Los Angeles, I was pretty fearless, and I could recognize an opportunity that just needed some tinkering in order to manifest. But part of the journey was also due to a restlessness in me, an inner thrashing and impulse to experience as much as I could every day.

So much about me changed while I was abroad. Before I went to Kenya, my reading and conversations gave me a vague understanding of the concept of female genital cutting, and I reacted with an opinion. In conversations, I voiced a nascent rallying cry against it. At the same time, I had the words of the recently-returned-from-Kenya young man's warning echoing in my head against having such an opinion. While in Kenya, I was dis-

Above: Teachers from Friends
World College, Kenya, 1988.

41

abused of my initial reactions to female circumcision in part by the young girls who believed that they would not become women without first going through the grisly procedure. Introjection—the psychoanalytical concept of the unconscious adoption of the ideas or attitudes of others—was at work on me. I couldn't help but begin to see things through the eyes and experiences of the Kenyan girls, though I remained a headstrong young woman who usually spoke her mind.

What follows is a transcription of my journals written while I lived with my Maasai hosts, and some additional entries from the period immediately following my travels. I have inserted commentary—a sort of talmudic marginalia—written now, as I look back at myself then, to provide context and to express my now expanded perspective. The photographs included are some that I've selected from my stock of many more from that period. The journals and the photos tell the story of my time in Maasailand, which, maybe predictably and maybe not, went far beyond ritual and into the culture from which these celebrations are derived. I learned that life's signposts read differently when the culture from which they emanate is steeped in facts and histories so different from those to which I was accustomed. My journals tell the story of a cultural experience with a voice that is both familiar to me and foreign, as it is the echo of myself from more than two decades ago.

Opposite: This young Kenyan girl likely would not have completed her education. Today, her chances of doing so are much better.
Following pages: The author poses with the olboni of the Maasai wedding she attended.

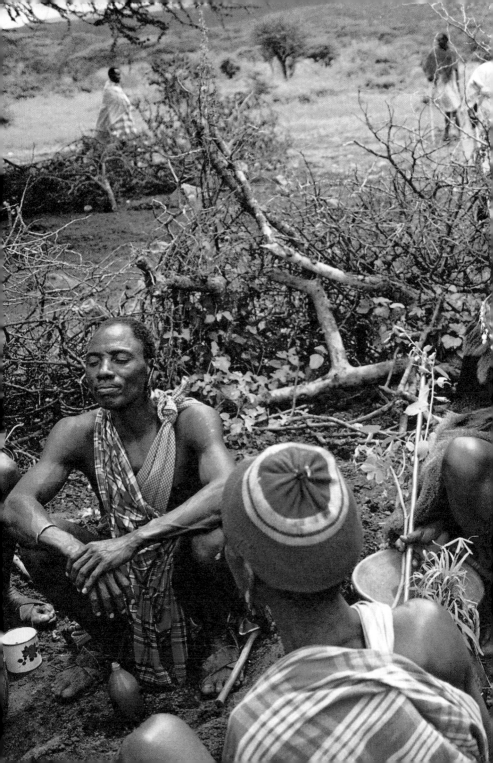

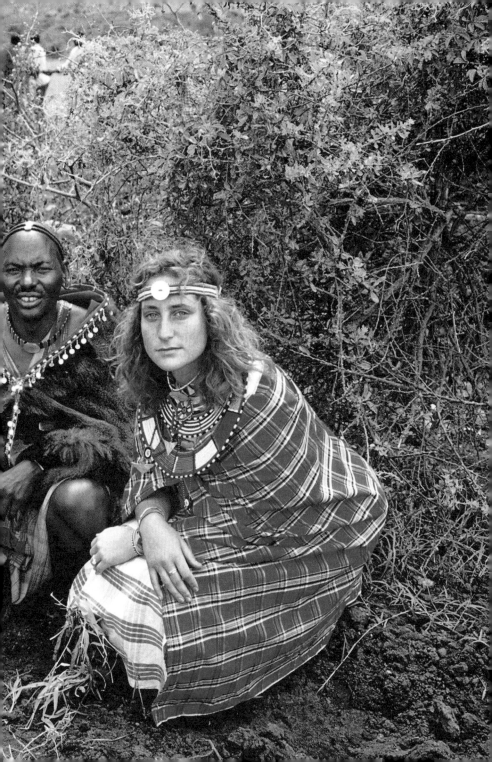

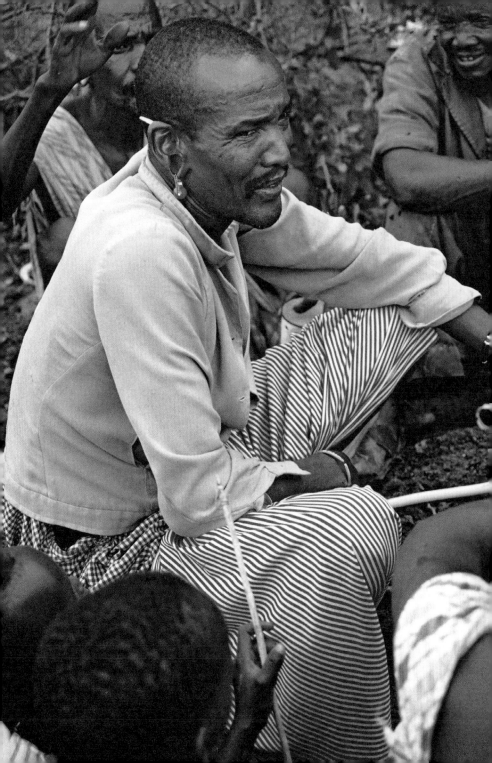

2

CALIFORNIA

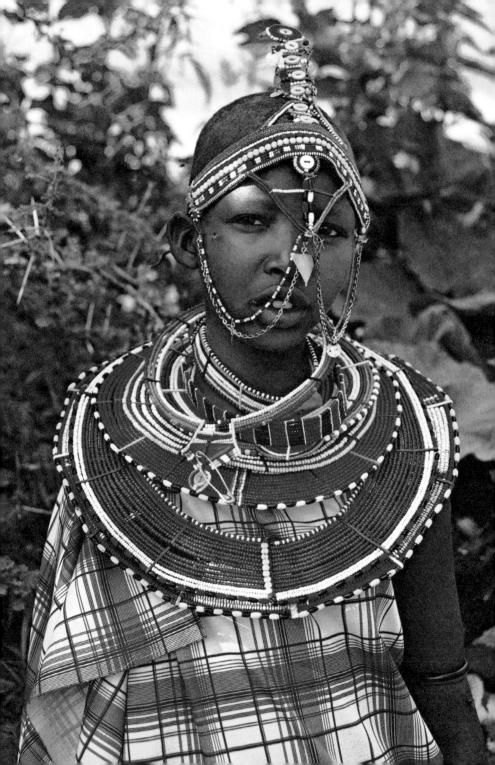

REFLECTIONS, WINTER 1988, CALIFORNIA

We Westerners are so easily taken aback by photographs of the Exotic, the Foreign, and the Primitive. We often assume the photo is only casually posed, if posed at all. We assume authenticity. We assume the photographer's neutrality unless we are otherwise informed, yet, as we experience the imagery, we are unconsciously led somewhere by the photographer's choices in creating and rendering the image.

When I produced my camera in Maasailand, I created an occasion and a diversion from the norm. Machinery is always an occasion in rural Africa. There is never a natural atmosphere when a camera is present. Beads, thimbles, tape cassettes, watches, nail clippers, ballpoint pens with or without ink, and even the blue sticks from American Q-tips are all objects of curiosity and play. They are decorative, durable, and unusual, and these qualities transcend purpose. My black, hard, hand-size camera is a mechanized object with moving parts that makes noise when touched. It has small pieces of beautiful, curved, perfect glass. Few rural Africans I met had ever looked through a camera's lens onto their world.

By now, very nearly all Kenyans have seen photographs; many have even seen themselves in color prints. But the excitement of possessing a photograph, particularly of oneself, is great. The accumulation of photographs is ultimately a sign of prestige, even to the point that many Kenyans have photographs of total strangers in their homes. And yet I hardly need to mention that there are many people who refuse to be photographed. In fact, over the years, a number of Kenyans determined that even better than refusing a *mzungu* (non-African) a photograph is to actually charge him for one.

Opposite: Tea wearing her mother's beads and headdress. This photo was taken within the first days of the author's stay, and there is a formality in both the dress and posture of the subject that fades over time.
Page 46: Elder warriors socializing.

I went back recently to look at the photos I had taken during my months in Kenya and asked myself about their authenticity. How posed were my subjects? How naturalistic are these images? At what point during my stay did I take the photos, and how comfortable were we, my subjects and I, together?

Coffee-table books and documentaries on "Native Africa" present these Africans as pure and unaffected by modern society. This is not always a fair representation. A people may collectively and without conference choose to maintain traditions and a traditional way of life, but modern influences are never completely avoided.

Cars and radios, couches and corrugated tin roofs are all found in the (seemingly) most remote of places, yet in art, in books, and on film, we still find representations of Africans as the fierce, traditional, not-yet-discovered, proud, exotic-yet-noble savages standing lone and unwavering in traditional clothes, smiling a Mona Lisa smile full of distance and mystery, completely out of reach from the viewer.

Though they might be different from Western social structure, the ethnic groups in East Africa have their own hierarchies and social ranks. The agricultural communities feel superior to the pastoralists because they own land and consider themselves masters of it by virtue of their farming and animal husbandry practices. The Maasai, who today are pastoralists, historically lived a nomadic existence as they traveled down the Nile, believing that their universal and spiritual domain over all cattle on earth necessitated their moving along with their herds, though now they are limited by reserves and land allocated by the government. Beneath the pastoralists in this structure are the hunter-gatherers, as they have no domain, no possessions, and exist like squatters on Africa's soil.

The Kenyan Maasai are unabashedly xenophobic and tribalistic. They have disdain for their fellow Kenyans, and they feel superior to the Tanzanian Maasai in all respects. They regard Westerners as absolutely moronic and useless, beyond help.

There is also a tremendous amount of prejudice in Kenya directed at the Maasai. Other Kenyans, particularly those in the majority ethnic groups

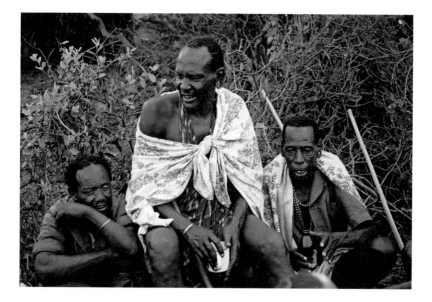

and those in the main population centers of Nairobi and Mombasa, freely comment on the Maasai's audacious arrogance, given their backward, blood-drinking ways. They decry the stupidity of the Maasai's rejection of modern realities, their rejection of the "real" world. They assign this stupidity to a monumental genetic defect. These other Kenyans will then speak of the inherent superiority of their own tribes, particularly through the lens of their successes and rise in modern Kenya.

While I was there, the government was trying to outlaw Maasai warriorhood in yet another attempt to civilize the barbarians. So many of the Kenyans I spoke to were embarrassed by the Maasai, by their loose shukas and walking sticks and virtual nakedness in Nairobi.

Above: Elder warrior enjoying beer and conversation.

The first Maasai I saw was actually in Malindi, a coastal tourist town north of Mombasa. I saw two shining tall men, who seemed to glisten red in the white sunshine. I grabbed my girlfriend and started to follow them. Without turning around, the Maasai warriors knew we were behind them. They turned into a restaurant in which they would never eat. We followed them inside only to find them waiting for us with their arms crossed.

They looked above our heads and walked out the door. Feeling ashamed and found out, we pretended that we were planning on eating at the restaurant and sat at a table for a while. We left only when we were sure they must have been long gone and found them waiting for us just outside.

"Jambo." They greeted us like tourists, smug and deliberately insulting, at least from my perspective. I hated that greeting after having been in Kenya for as long as I already had. A hazard of living somewhere foreign for a long time is that one often forgets what one looks like, and I was certainly in the habit of forgetting that I was white.

"Supa," I replied

"Supa?"

"Supa," I repeated. I don't think they expected that I would know the Maasai greeting.

"Ipa!" They responded with big smiles and warm handshakes.

I remember feeling triumphant: I had risen above Maasai prejudice, at least for a moment. This was before I had decided to spend a period of independent study living with a Maasai family where I would have to stand my ground and assert my humanity on a daily basis.

Opposite: Against the backdrop of Acacias and blue sky, a mother holds her curious daughter back from the author, who has a new and different face.

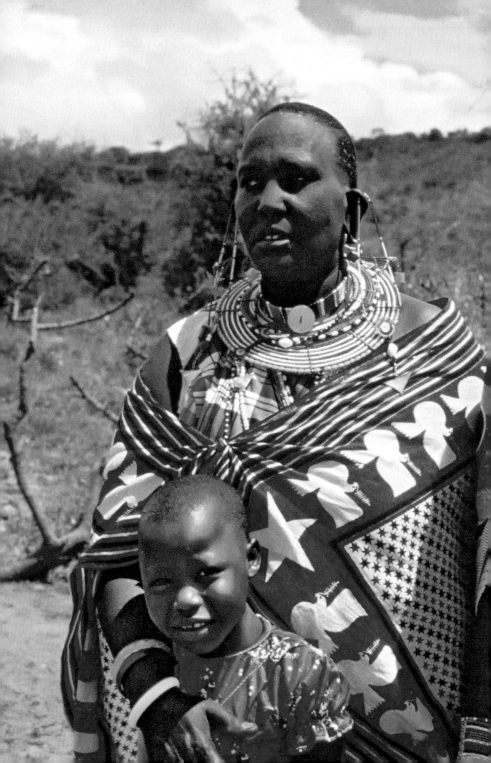

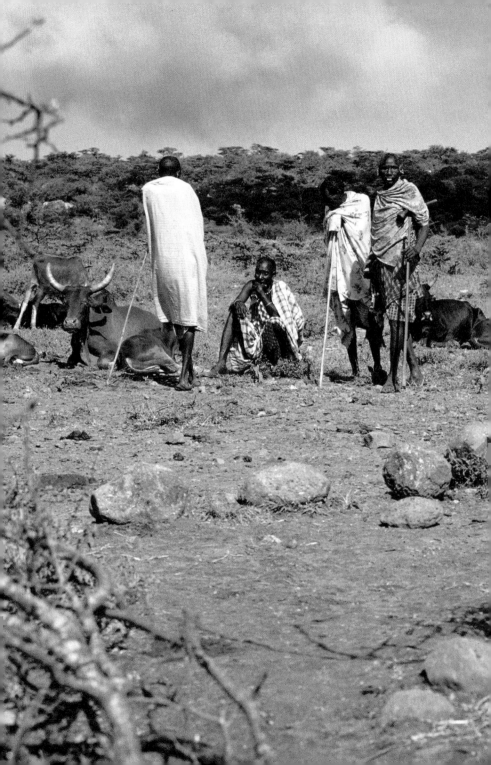

3

THE BUTCHER
AND HIS BOMA

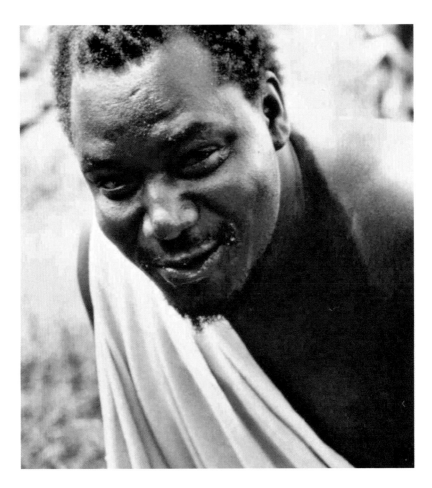

Above: Kimutai with his face covered in fresh goat's blood.
Page 54: This photo was taken through the brambles of acacia branches,
looking into the cattle pen of a boma.
Following pages: Sintamei and Naserian on the day of the author's arrival.
For the photograph, Sintamei wore every piece of jewelry that she owned.

Aboma only houses members of one extended family. Kimutai, the Maasai butcher from Nairobi with whom I was going to stay, was the head of his boma. As such, he was the undisputed, never-to-be-challenged leader and dictator of all things. All of the other men were subordinate to him, so much so that I don't even have their names recorded in my journals. Kimutai had the big chair in the boma, an anomalous big belly amongst the tall and thin Maasai, and the biggest heads of cattle. He had first dibs at every slaughter: His face went into the skin flap of the neck of the just-dead animal, and he took big draws of blood that pumped out of the jugular vein into the space between its neck and its hide. He decided who got how much of everything. He was the only formally educated man in the boma, and he was its leader . . . but he was the sort of leader who saw his family as his subjects. He was unpredictable and not always kind.

Sintamei was Kimutai's only wife. Like all wives of warriors, she took on the age-set of her husband (all similarly-aged young men go through their warrior initiations and succeed—or fail—as a group), and her status was elevated by Kimutai's wealth and position as the owner of his own ranch. She was the queen of the hive and was often cranky and impertinent to everyone else, including Kimutai. She was also sneakily kind and would make cabbage on some days, a culinary gesture that I appreciated.

At twenty-one, I didn't understand marriage or motherhood. I was innocently enjoying Sintamei's hospitality. But if I imagine my husband bringing a young, exotic woman to stay in my home, without my permission, and if our culture promoted polygamy, I cannot believe that I would be anywhere near as hospitable to her as Sintamei was to me. While there, I never quite understood the threat I posed to her. Now, looking back, I do.

Sintamei's closest confidant was the delicately beautiful Naserian. Naserian was married to one of Kimutai's subordinates, and she showed both deference and loyalty to Sintamei. I loved photographing her, and I responded to her gentle nature, but my memories of her are far more vague than the ones I have of Sintamei and Kimutai.

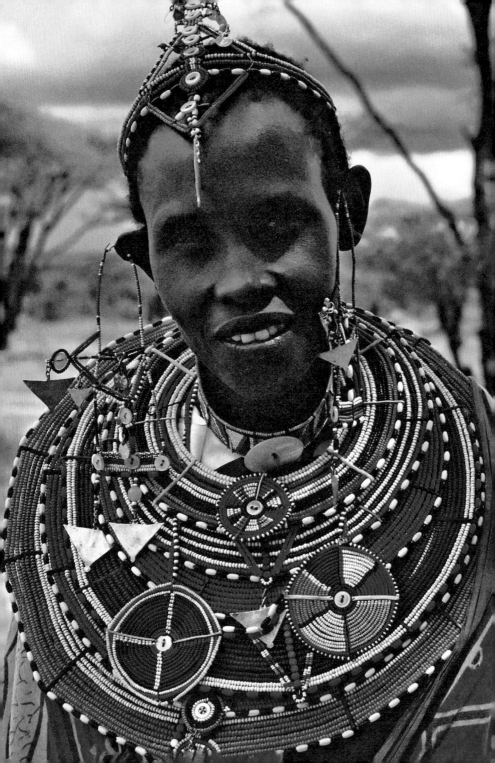

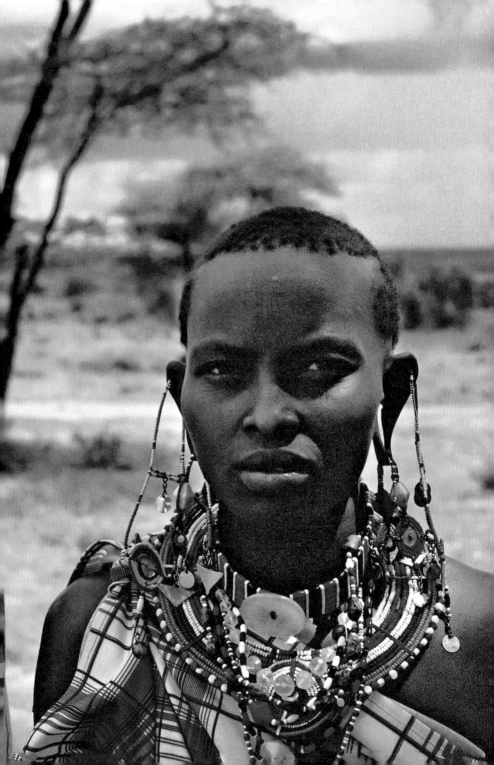

Tea, sweet Tea, was Naserian's adolescent daughter. She had not yet been initiated into the world of women, such as it was. Of the women, she was the least inhibited with me. She and I spent days entertaining the younger children and trying to figure out how to communicate. We found the best methods were pantomiming, pointing, and persistence.

WINTER 1988, CALIFORNIA, CONTINUED

I found my way to Kimutai through Erastus, my Swahili teacher, an educated Maasai whose one regret was not having disobeyed his father and become a *moran* (warrior). He showed me the ritualistic burn scars on his stomach, hidden in his work clothes, and lamented that he'd never had his ears cut. His Maasai-ness didn't show. His father had fought with the Mau Mau during the revolution but then insisted that his son, my teacher, get an education so that he would not have to repeat the horrors of the father's youth. Erastus had once tried to flee school, he said, when the warriors came for him. His hair was starting to grow out in preparation for his initiation ritual when his father sent the police with instructions to find and beat him before forcibly returning him to school.

He and I bonded. I wanted so much to connect in a spiritual way to this culture that was so foreign and magnificent. I wrote in my journal after meeting him, "He knew what I was saying without my going into any deep explanations. He understood me. He even described what happens when warriors get together: the uncontrollable shivering they experience when they chance upon another warrior from their age-set and the spontaneous song that ensues. He told me how warriors share things—beer, meat, milk, women—as if they were all a part of one perfect and complete organism with no weak points, no hungry parts, no facet wanting anything."

Erastus introduced me to Kimutai in Nairobi, and Kimutai introduced me to his family at his boma near Mile 46. Kimutai didn't like his family to stray far from home, so though he was technically my "host," in fact it was the family he kept disconnected from modernity who would be my sisters,

brothers, aunties, and uncles. Kimutai was proud of his wealth of experience, and on a few occasions while I was there, he reveled in the deliberate denial of experience to his family. He assumed that his worldliness and position made him seem superior and elegant to me.

Kimutai spent his weeks in Nairobi and came home weekends to be with his family in Maasailand, where they followed Maasai traditions. Unlike most Maasai, he was fat because he no longer lived on the traditional Maasai protein-only diet of milk and blood, with occasional meat. Nairobi afforded him the luxuries of beer, french-fried potatoes, and lots of beef. He spent most of his money on himself, returning home drunk to his family with pockets filled not with shillings but tins of snuff. He was a powerful man in the area due to his wealth and the fact that his brother was the chief of Kajiado, the region in which they lived. He commanded respect, though only Maasai men demonstrated "respect" as I would define it. Women showed respect by staying out of sight or by bringing milk or tea with their eyes downcast.

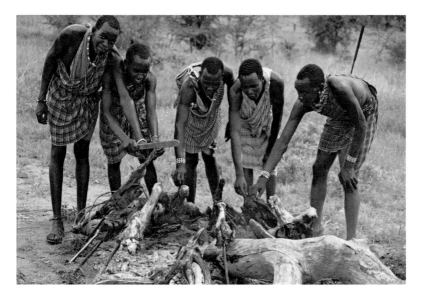

Above: Warriors roast meat from freshly slaughtered animals.

The way that I entered into this society was only possible because of Kimutai. Had he not been a man of such high standing, I would have been in danger. It would have been exceedingly difficult for my family or friends to find me if something happened: There were no roads, no modes of public transportation to the small homestead. There was not even law enforcement. As I eventually learned, however, his suspicions of why I might want to be there were unrelated to why I actually did, and his interests in me were not virtuous.

His understanding of white women, as is the understanding of many Kenyan men, is that we go to Africa to find an exotic man—and who more exotic than the tall, black, regal Maasai? There is a magazine in Kenya called *Drum* that printed an article that was reprinted multiple times by popular demand. The article was written by a man named Malimoto and is about how to show a white girl a good time and why savagery is a fair part of the exchange. A word-for-word sample:

> To meet a black intellectual kills their genius. It disappoints them. They are out in search of raw, brute, savage Africa. They want to visit the Maasais and the Karamajongs in order to see their long naked spears. It is not equals they came to see but lower humans they had volunteered to uplift. These are the unequals they reward on their own terms by offering their friendship.
>
> It is a real savage brute [for which] they search to give them a real native uninhibited experience uncouched in silly niceties and subliminitory [sic] preliminaries. Something near to a rape. In fact, if you approach a [Peace Corps girl] like a real native, you will make it. But then, in public, they will not know the difference between you and the next gorilla.

Kimutai was on the hunt for another wife. This was one of the things I did not yet completely understand, though I had my suspicions. I was just beginning to read the social cues and signals of my new family. I spoke fluent Kiswahili, the national language of Kenya, but I spoke no Maa, the

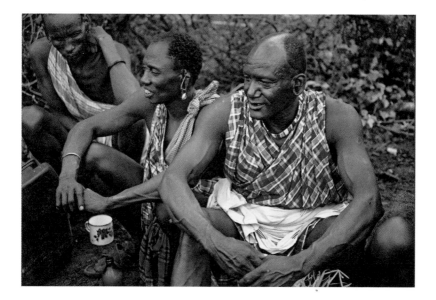

language of the Maasai. I had no way of communicating with the women who would be my most logical connection during my time in their boma. There was no set standard, no protocol for any of us to follow. Their lives' balances were immediately upset by my arrival, and none of us were prepared for our cohabitation, sharing both a hut and a bed. I did not have any formal preparation or training, nor did I have a guidebook or text to refer to. I did not know anything about the social order suddenly surrounding me.

When I look at the photographs from my first days at the boma, I see in my subjects' faces what looks like displeasure and resentment: What is she doing here? Why must I be photographed by this stranger? Kimutai ordered his family around for me and my camera, and I took his orders to them as my signal to accept the privilege. At first I was flattered, rather tone-deaf, and without too much thought, I shot away.

Above: Elder warriors enjoying their beer.

After several days, I began to realize just how posed the photos were, how uncomfortable. As they so often do, the camera changed the atmosphere and postures of my subjects and put my new Maasai hosts on guard. Naturalism was not possible. Further, Kimutai's special (because I am Western) treatment of me, his deference and respectfulness, made me an unwelcome new factor in his family's preexisting understanding of their internal hierarchy, and, more essentially, it made me a threat. Kimutai's wife, Sintamei, regarded me with darting, jealous stares. Her sisters-in-law in the boma naturally took to her defense, treating me as an exigent curse that would take the form of Kimutai's second wife. It seems to me that only the Maasai men are enthusiastically polygamous.

I unwittingly reveled in the special treatment and took advantage of Kimutai's generosity; that is, until I realized the negative results of it. It took me a while to bridge the distance that existed between the women and me after spending so many long, equatorial days in the company of their men. My motives were unclear to them. Kimutai had not explained my presence to anyone. He just boasted about having an American girl in his home.

The tension of this situation shows in the faces of the women in my photographs. The excitement in some of the men's faces is accounted for, too. The children, unsuspicious and unaware of the social dynamics, appear most comfortable in some respects. In many of the photographs, however, their expressions reveal the confusion and unfamiliarity of their interaction with the camera and with the first white person they had ever met.

Opposite: Young girl poses in Tea's beads.

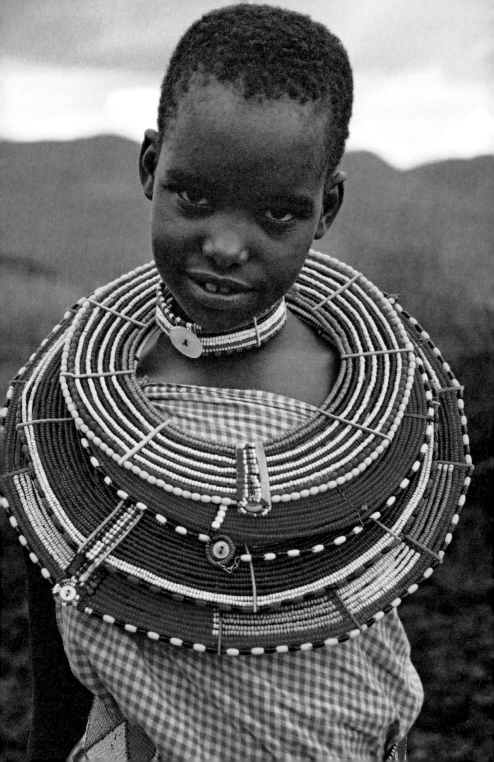

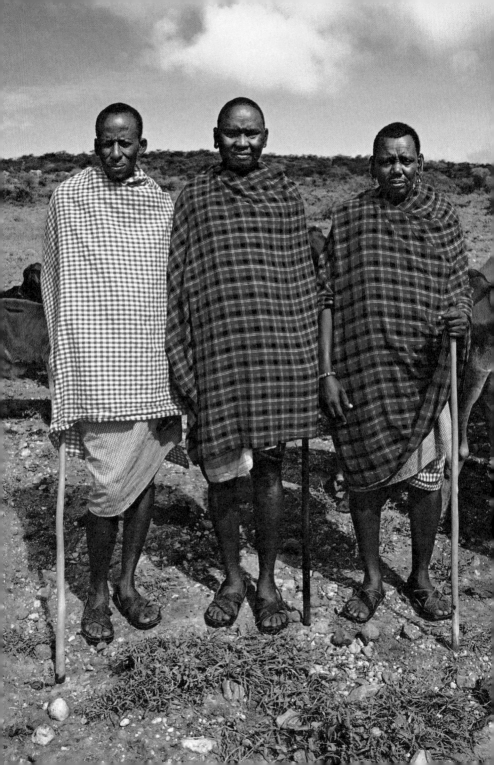

4

A WEEKEND WITH MAMA SIMU

Before I went to stay with Kimutai, I visited another student named Greta. She was spending time in a Maasai boma very close to Nairobi. Greta's host, Mama Simu, was known locally for her beautiful beadwork. This seemed to me a great opportunity to introduce myself to Maasai culture with the cushion of the family having hosted an American before me.

Greta was having a terrible time with Mama Simu. She had not learned Maa, and her Kiswahili couldn't get her past ordering a beer. When I arrived, she looked so relieved. Until that point, she had spent her days sitting by herself under a tree. But I had not come to visit with her: My goal was to get a sense of what my weeks with Kimutai might be like. These are my journal entries from those first days.

21 APRIL 1988
Boma of Mama Simu

So many flies. Everywhere. Room where visitors sleep stinks like sour milk. Cows and goats sleep in the same house I do.

Last night Mama's boys, Salaon and Tyrus, two lloimon, and I talked a lot about Maasai discrimination and rights. We also spoke of marriage and women's roles. Polygamy is so much a part of Maasai tradition, and it seems that Tyrus would take anyone for his wife. Anyone.

The conflict between modernism and traditionalism is, I think, more significant to me than to the Maasai. Some of the men are so eager to build a home with a corrugated roof but then refuse to live in it. It is as if they want the prestige of owning a modern amenity but don't embrace the reality of actually living in it. Like pants. Tyrus says one day he wants to have one modern wife living in a modern home in which he'll wear pants and one traditional wife living in a traditional house in which he'll wear shukas. For today, he's most proud of his newly dunged roof.

Page 66: Warriors who have just finished their
herding duties pose stiffly for the camera.
Opposite: Warriors with their sons on the savanna.

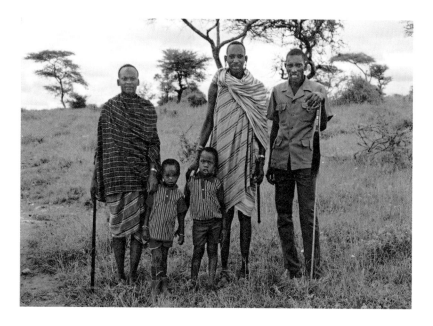

I just heard one lloimon shake the calabash full of that sour milk, drink it, snort, and sigh.

The visitors came to see if Naisiae would wed one of their warrior brothers. Naisiae doesn't wear beads. Since she had her baby, there's no need to wear them, she said. She's eighteen with a five-month-old daughter. Zenadria, the baby, started crying as we were talking, and Mama Simu pulled out her breast to comfort her. If I had to guess, Mama Simu is about sixty-eight years old.

23 APRIL 1988
Boma of Mama Simu

I smell like a Maasai: human and smoky and musky. The women here spend a lot of time indoors and keep a fire burning all of the time inside of these spiral dung huts. When they build the huts, they only leave one small hole for a window, so most of the smoke stays inside. My eyes tear each time I go into a hut, and my skin smells like burning acacia trees.

When I was leaving from my weekend visit with Mama Simu, I was the last person to cram into a small metal truck. There was seating for five, but there were already fifteen women inside the doorless vehicle. At that point, not even my entire foot could fit onto the floor, so I had only my toes, head, and shoulders inside the truck while the rest of my body was bent outside. I was holding onto a metal rail that ran along the truck's ceiling for the entire 12-mile ride to the town of Ngong on a path that, having been cleared of vegetation and oft-traveled, might at some times of the year be considered a road but for today had given way to mud from the seasonal rains and was now just a soupy mess.

The truck bounced and slid in the mud, and my back rammed repeatedly into the metal frame of the door. I could feel a bruise developing but was enduring the pain when a seated Maasai woman grabbed my hand and pulled it from the inside rail of the truck. My hand was behind her head and must have been annoying her, so she threw it off of the rail. I began to fall out of the truck and would have fallen completely out, but a man seated on the roof pushed me back inside. His forceful gesture to save me made my head slam into the truck. I cried.

Every woman in that truck stared at me in disgust. When we arrived in Ngong, I was pushed out of the truck and all the bags were thrown off of the roof onto the ground near me. The women rushed over to my bag and ripped it open in order to steal my belongings. I scrambled for my duffel and, like a bullied shopper whose tomatoes fall out of a ripped paper sack, politely and maybe too apologetically went to retrieve my belongings. My host, Mama Simu, who had been friendly up until this point, abandoned me at that moment and did not look back.

Opposite: Maasai woman transporting beer
with a leather strap across her forehead.
Previous pages: Acacia trees punctuate the
otherwise wide-open Mara landscape.

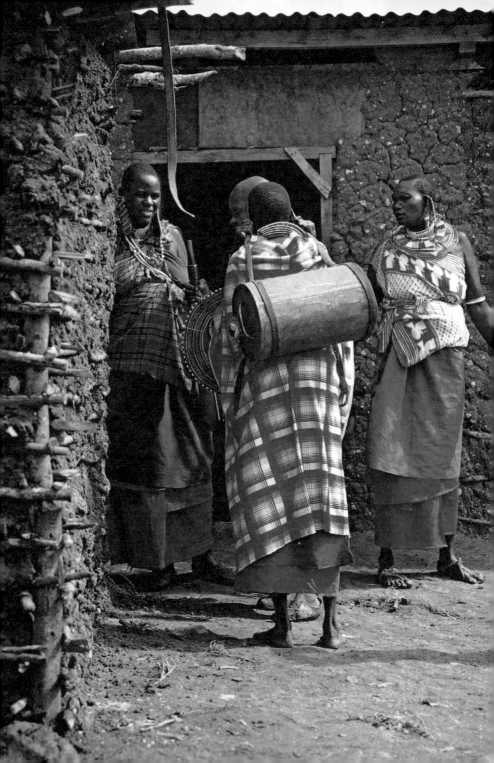

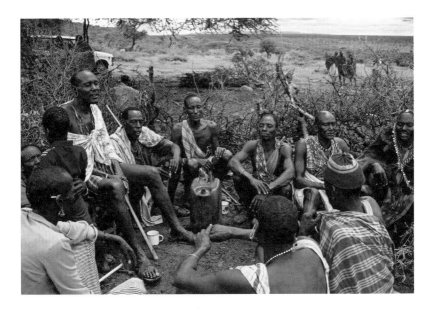

Above: Elder warriors settle in for snuff and beer.

Mama Simu, in addition to beading, collected used purified water bottles and refilled them with a garden hose to sell to tourists so they wouldn't have to drink the dirty Kenyan tap water.

Those two days with Mama Simu were my first days living among the Maasai. I had absorbed a few words of Maa while there and promised myself I would focus my energy on learning the language. I did not want to spend six weeks by myself sitting under a tree.

Mama Simu's lifestyle would prove to be very different from the lives of those who lived with Kimutai. In a way, Mama Simu was ahead of her time, or at least decades ahead of Kimutai's wife and sister-in-law, Sintamei and Naserian. Mama Simu was unmarried and an entrepreneur. She lived closer to the urban center of Nairobi and was more aware of her opportunities. By my standards, she was destitute, but by her standards, her life was good. She had a network of friends and various revenue sources and could survive without a husband.

At the time, I didn't consider the implications or benefits of being married or being single. My perspective was limited to my own experiences, and, at twenty-one, none of my friends were married and nothing seemed impossible. Mama Simu's life was unpredictable from one day to the next. Still, she was generous to host students in her home, and her hostility toward someone who was not useful or to one who seemed weak was understandable when her life depended on her wits, strength, and resourcefulness.

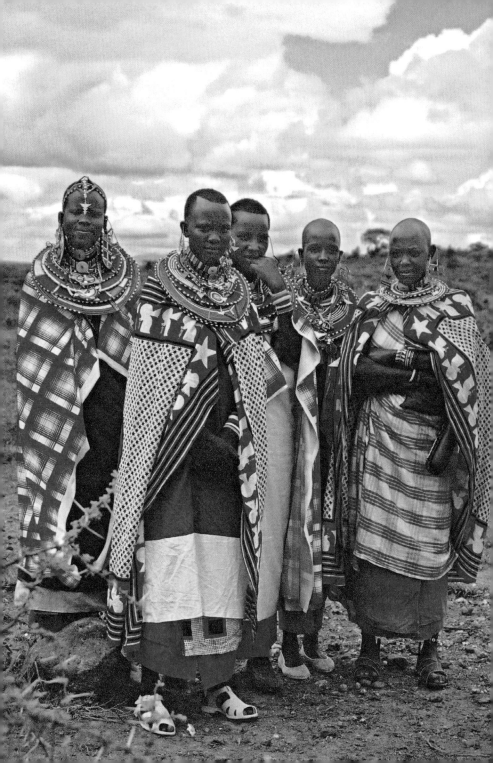

ARRIVING AT MILE 46

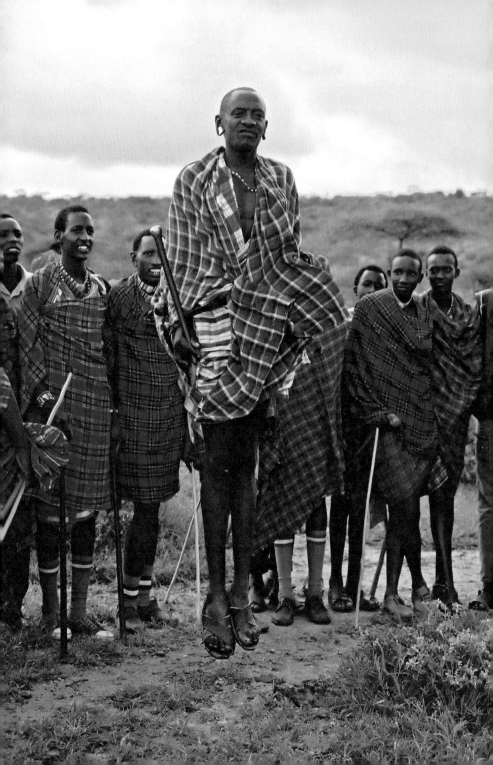

After my Mama Simu weekend not so far from Nairobi and another week or so studying and preparing in Machakos, I began my weeks-long stay with Kimutai and his extended family near mile marker 46. There were no marked roads, just as there was no plumbing, no electricity, and no phone service. The strongest impression I had of the place as I approached it was the unique landscape: the flat-topped acacia trees and the flat-bottomed high clouds coming together to create a big, blue sandwich of sky.

The intensity of my experience with the Maasai family and the largely non-verbal form of communicating while in Maasailand stripped away any formality or performance in my writing. These entries were more intensely private than anything I had written up to this point while in Africa, in part because there was no one that could read them and in part because there was an expectation that no one ever would. They were the only thing I did in English, and my solitude impacted the weight and balance of each word, just as the lack of words in my social communication changed the weight and balance of those interactions. The journal entries were beautiful and spare, reflecting the environment in which they were written.

During my first days with Kimutai, I remember a Coca-Cola delivery truck getting lost somewhere near our boma. The truck got stuck in a crevasse on a dirt path. Like swarming insects, the Maasai children came out and grabbed all of the bottled soda they could hold. The driver simply abandoned the truck and started walking back in the direction he came. The truck was stripped clean by the end of the day.

Page 76: When the author first arrived, the Maasai women were not keen on her.
Opposite: Elder warrior jumping, surrounded by junior warriors.

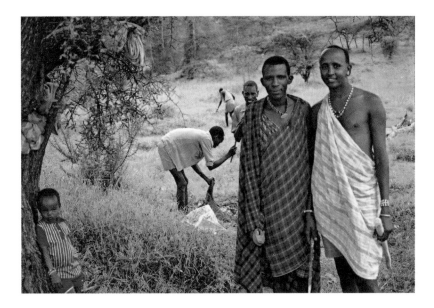

MAY 5, 1988
Kimutai's boma

Yesterday I waited and waited for my ride to this boma. We finally got here, and it was just a bit awkward. I think Sintamei, Kimutai's wife, thinks I am to be his second wife. Not to worry, Sintamei. Kimutai let me sleep with Sintamei, and he slept in the entry with all of their children.

When they are young, the Maasai are taught to speed-walk on the balls and toes of their feet so as to be able to walk very fast over very long distances. They look like they're bouncing, hence their nickname, the "Spring Warriors." We are going to Kajiado tomorrow for a party to welcome me.

Above: Warriors and a little boy pose in the foreground while more warriors slaughter a goat in the author's honor in the background.
Opposite: Elder warriors pose with a local Maasai official.

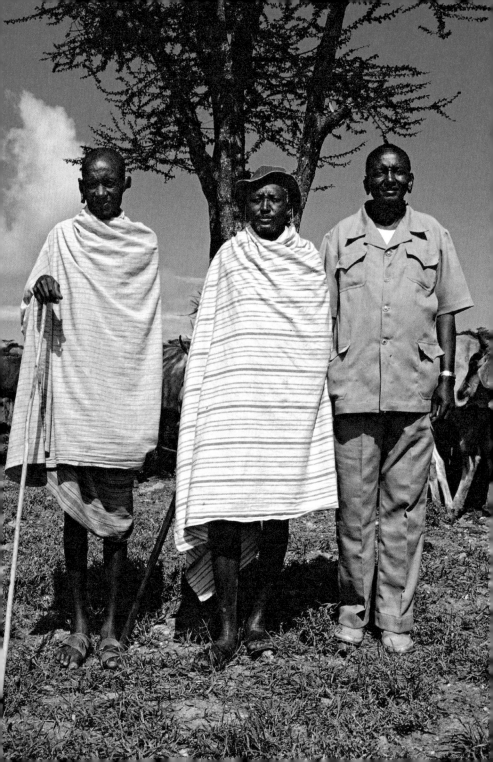

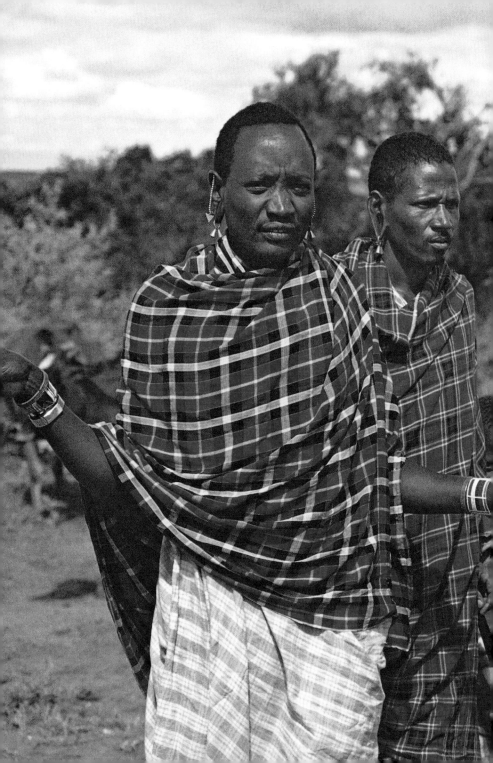

6 MAY 1988
Kimutai's boma

They slaughtered a goat today in my honor after I met everyone. It was amazing.

This is how they butcher: First they suffocate the goat by kneeling on its body, pinning its legs, and blocking its nostrils while clamping its mouth shut. When the goat settles down but is not yet dead, the struggle is less violent, but they keep holding the nostrils and clamping the jaw shut until the goat is completely still, and they can't feel a pulse. Finally, they begin to systematically cut the body.

The warriors empty the intestines and the goat's three stomachs all over the grass. They feed the warm kidneys fresh from the goat to the children, and the little ones gobble them up like they were cookies straight from the oven. The men drink the warm blood from a flap of hide cut from the goat's neck next to the jugular vein, but once the blood begins to cool, they collect the remaining liquid in a pan for cooking later. When the men offered me some blood, I demurred by saying I wouldn't want to take any strength away from the warriors. They liked that.

The slaughter is always done under the same tree, and the audience that had come to watch included a very big bird and innumerable flies. Dogs fight for the eyes, the guts, and the detritus of what was, moments ago, part of a living animal.

I also met a couple government officials yesterday. One worked at the Ministry of Agriculture. and he explained, with pride, natural Maasai family planning. Specifically, he spoke about how a woman will not sleep with a man if she has a child who cannot yet walk.

He continued, explaining that traditionally, warriors would not have sex with anyone but were now just forbidden from sleeping with circumcised women, making prepubescent girls the only allowable indulgence for

Opposite: The two other warriors who reside in Kimutai's boma.

the warriors' sexual appetites. At the *eunoto* (warrior initiation ceremony), the warriors must walk through one gate or another before all witnesses: virgin or experienced. While he said that tradition dictates that it is preferable for a warrior to be a virgin at his eunoto, he added in the same breath that the warriors' mothers encourage their sons to sleep around for their reputation's sake. These same mothers craft beaded ornaments for their sons to wear at their eunoto, he said, "in order to attract and impress the young, uncircumcised girls" who would be their sons' prey. An interesting aside: Warriors are not permitted to drink milk or eat alone ever. They must always be with another warrior. The warriors and their mothers live separate from other family groups in a *manyatta*, a boma that houses only the warriors and their mothers.

Kimutai told me that the Maasai believe that they are one of the lost tribes of Israel who traveled down the Nile, like their brothers, the Somalis. He said they believe that they are brothers and sisters of the Jews and that they are "just as tough." In fact, many Maasai have blue eyes, and, like the Jews, one of their dietary traditions is to never eat milk with meat. So, I guess, anything is possible. One *mzee* (old man) told me that he likes me because I am very much Maasai. *Sidai oleng, mzee.*

Opposite: Elder warrior squatting against a hut, drinking beer.

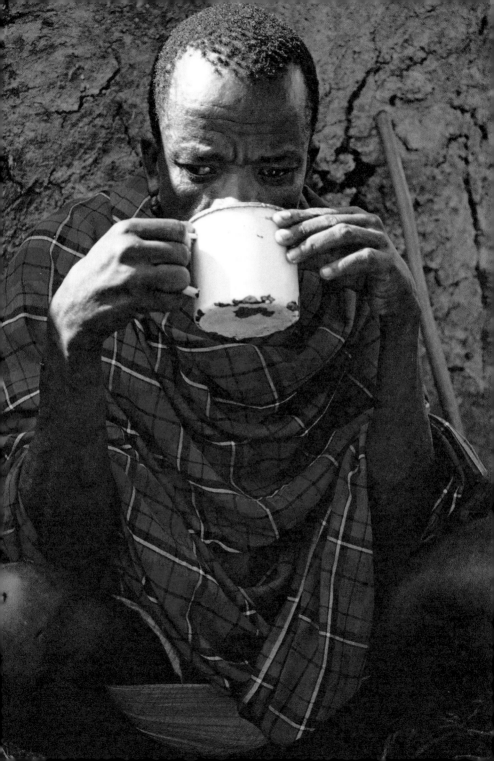

ON MAASAI CULTURE

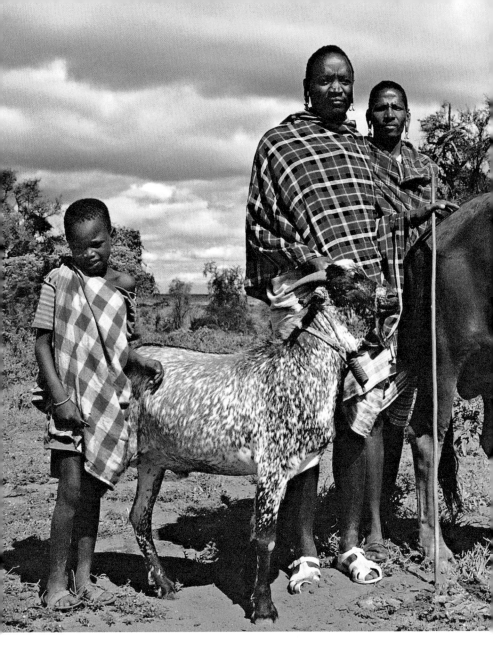

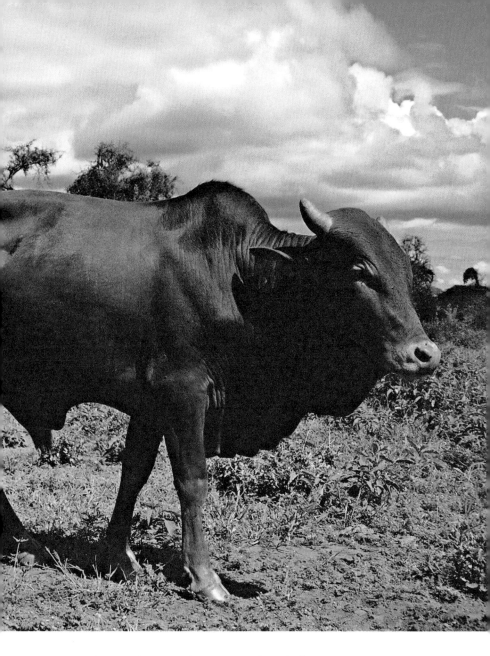

Above: The men of Kimutai's boma pose with one bull, one goat, and one boy.
Page 86: An olboni in his ceremonial baboon-skin cape, posing with his first wife. The younger warrior holds calabashes with fresh grasses for an upcoming ceremony.

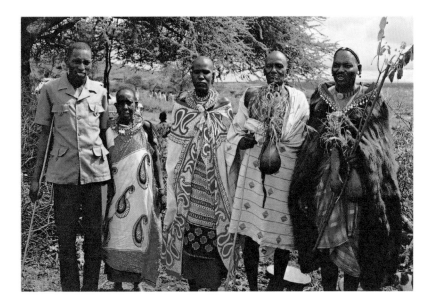

Above: The olboni poses with a member of his age-set, his
wife, a local official, and the official's wife. The olboni holds
the sacred branch that will be affixed to the house where a
girl will be circumcised; his warrior brother holds a calabash
with fresh grasses, which signify a new beginning.

Maasai life is imbued with ritual and traditions that are often lost in translation, even in Kenya and Tanzania. Many Maasai practices have ancient roots, and because of their rejection of modernity and their diet of meat, blood, and milk only, detractors consider the lifestyle and spirituality of the Maasai to be primitive. Other Kenyans told me they felt the Maasai lived a life that was simplistic and anachronistic and that their unwillingness to assimilate isolated them from the rest of the country in more ways than one. The prejudices of the other tribes and the implementation of laws and institutions, including designating game reserves that had been Maasai grazing land for countless generations, have, over time, eroded the Maasai population and its way of life.

At the foundation of Maasai life is the belief that cattle are their divine providence. A Maasai prayer commonly recited is *Meishoo iyiook enkai inkish o-nkera*, which means simply "May the Creator give us cattle and children." The Maasai prize their livestock, and so much of their belief system and day-to-day existence is informed by the role their cattle play.

Colonization of Africa changed how many nomadic peoples lived. The national borders—arbitrary to the tribes who had inhabited the land for many generations—and imported governments have affected the movement and lives of the indigenous ever since colonization began. Eventually, when Kenya established its national parks system, including the Maasai Mara Game Reserve, most Maasai were cut off from the best grazing land and water sources, which were now allocated to the parks. Tilling the soil to farm is against their religion, as doing so ruins the land for grazing, but many Maasai were forced to start farming to survive.

Some Maasai fully abandoned their traditional lifestyle, like my Kiswahili teacher, or did so partially, like Kimutai. While many of the traditional rituals survive today, it is difficult to imagine how much longer they will continue on, given their many opposing factors.

Traditions have concrete meaning to Maasai, from the lion hunt and the warrior ceremony to weddings and circumcisions. All of these rituals represent a passage from one phase of life to another and add dimension and character to a person's life.

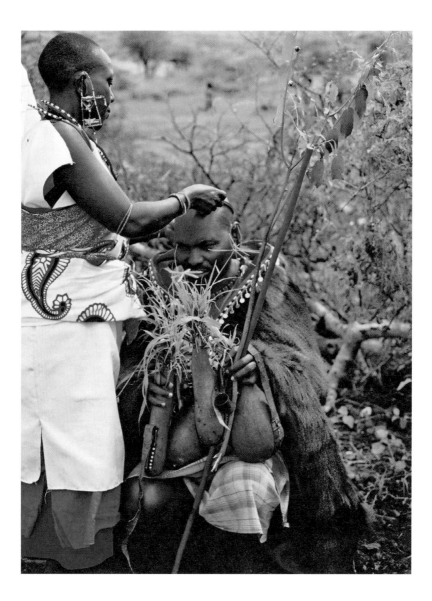

Above: To prepare him for his ceremonial duties, the olboni's head is shaved and ochred. Now his wife is laying beads upon it. He is holding calabashes filled with milk and honey.
Opposite: In ceremony, the olboni passes a calabash to a senior elder warrior.

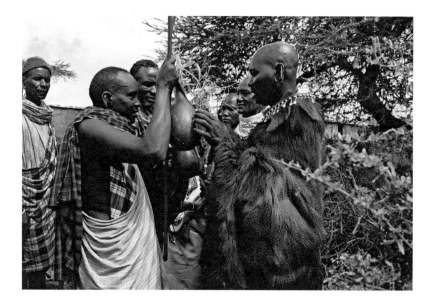

A Maasai boy's life is marked by distinct phases, beginning with his pre-circumcision childhood. Between the ages of fourteen and sixteen, he begins a years-long series of rites that take him from adolescence to adulthood and prepare him to be the head of his own household.

As a teenager, all Maasai boys are assigned to their *orporror*, or age-set. This is comprised of a large group of teens from his clan of approximately the same age with which he will elevate through Maasai society into adulthood, warriorhood, and eventually elder status. When they are first assigned, the age-set will walk the Maasai territories for many months, announcing itself to the people and collecting members. Eventually, the boys will move into an encampment where they prepare for their ritual circumcision or *emuratare*.

Circumcision is perhaps the most important rite of passage, as it marks the threshold between boyhood and manhood and represents a spiritual portal through which the boys will become junior warriors. Once he is healed, a young man begins his life as a warrior and moves into a

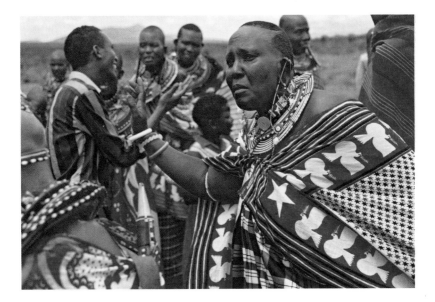

manyatta, an encampment of thirty to forty houses, with the other boys of his clan's age-set and their mothers.

In the almost ten years the boys spend in a *manyatta*, they will let their hair grow out to symbolize both the purity of their mission and their transformation from boy to man. This is the only time we see a traditional Maasai man with dreadlocks. The junior warriors live absolutely communally, never allowed to eat alone or be outside the company of the boys from their age-set. It is during these years that the young warriors might embark on a lion hunt.

Historically, the Maasai hunted lions by themselves. Much to the chagrin of wildlife conservationists, animal activists, and game park management, lion hunting continues today, as the Maasai believe hunting such a powerful animal demonstrates their bravery and prowess. The Maasai who still maintain this practice no longer do so alone but in age-set groups to demonstrate one age-set's superiority to its predecessors. The hunt has to be done in secret. It is a point of pride that the hunting is done with only

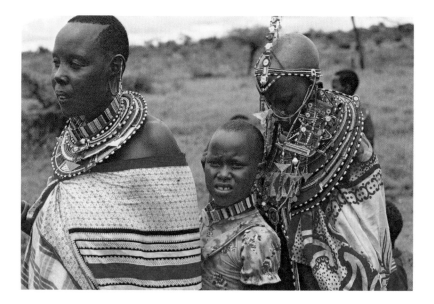

a spear and a shield, and the warrior who slays the lion is guaranteed a lifetime of praise and legendary status.

The young warriors sneak out of their *manyatta* before sunrise, and the elder warriors supervising the hunt pick the hunting teams. The youngest warriors are often rejected outright and, armed with clubs and shields, will start to fight with their elders in order to prove they deserve a place in the hunt. Once the teams are established, the warriors go to places where they know lions will be. They only hunt male lions, sparing the females the spear due to respect for their ability to procreate. The group will provoke the lion until a warrior lands his spear and kills the animal.

Opposite: Like a street hawker, the mother of the bride calls for community gifts to go toward her daughter's dowry. *Above:* The bride, with her head bowed and eyes downcast, inches slowly toward her groom, only stepping forward when a community member has answered her mother's call for contributions to her dowry.

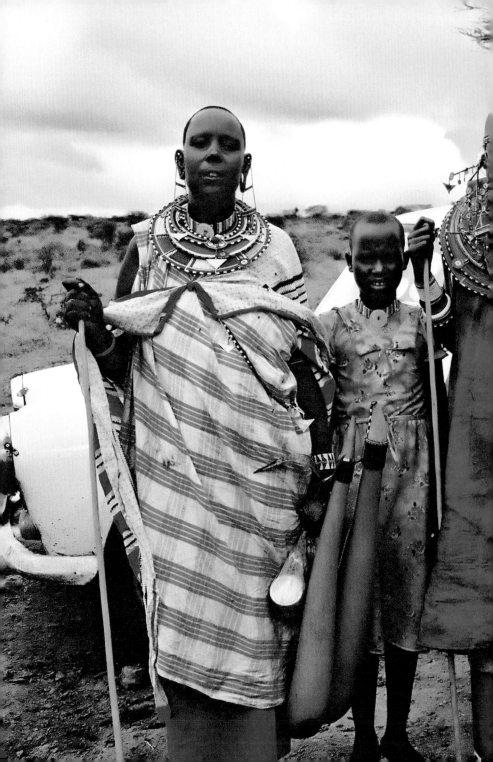

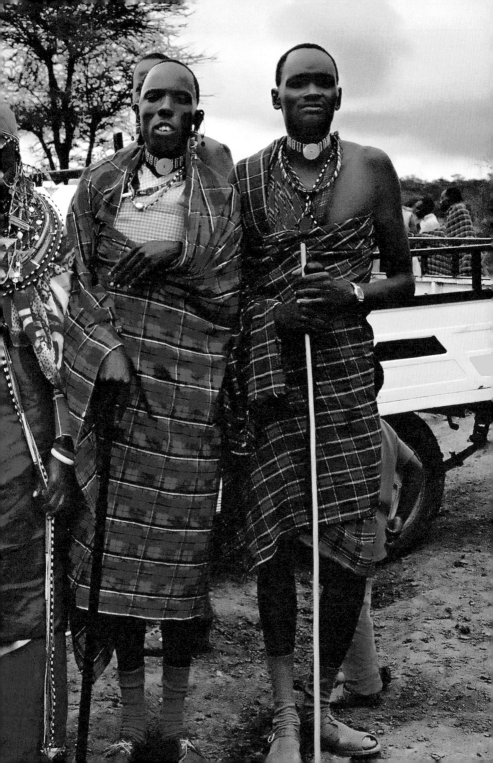

When they return to the *manyatta*, the warriors' mothers bead the lion's mane, and the lion-slayer will wear the mane as a headpiece during all future ceremonies until he leaves the encampment. Upon leaving the *manyatta*, the slayer's mother slathers the man in animal fat and ochre, and the Maasai warrior abandons the mane forever. They do not eat the lion, for their religion prohibits the eating of wild game.

After the *manyatta* years, the day comes that will mark a boy's entry into his senior warriorhood when he will go through his *eunoto*, which is more like a festival than a ceremony. The *eunoto* will take place at another specially selected location, one with exactly forty-nine houses. In the forty-ninth house, the *olboni*, a spiritual leader and prophet, will expect to be entertained by stories told by the young male residents of the encampment. The boys will gather around a fire into which an animal horn is placed, and one of the boys must assume the curse of misfortune that comes with retrieving the horn before it is burnt to ash. If no one pulls out the burning horn, the entire age-set will be cursed.

Once the warriors complete their *eunoto*, they are released from their communal life into their independent ones, and they will begin to contemplate marriage. The final part of the years-long initiation into warriorhood is called *orngesherr*, and it signifies the junior-elder level of status when a warrior can start his own homestead. Up until this time, he will live in the homestead of his father although he himself may have multiple wives and children.

While at Kimutai's butcher shop in Nairobi, I asked him if he would be able to arrange for me to attend any ceremonies. My stay didn't overlap any warrior ceremonies, though even if it had, as a woman—particularly

Previous pages: The bride with her groom (second from right) surrounded by her younger sister and warriors from her groom's age-set. The bride will not look up until she is in her new groom's hut. *Opposite:* Strict adherence to the allowable colors for beadwork is expected, making innovation in pattern and design highly prized.

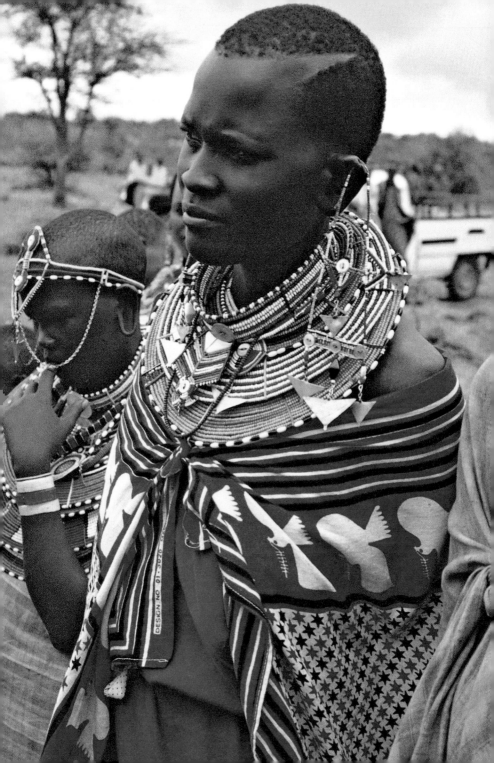

as a foreign woman—I wouldn't have been able to attend anyway. Very soon after I arrived there was a day when both an *enkiama* (wedding) and an emuratare would occur at once. During the morning, a young girl would undergo the torture of a clitoredectomy. While she was bleeding, another young woman, only a few years older than the girl, would take a long, slow walk to her nuptials.

The day was not celebratory in a Western-wedding sense. No band playing, no limousines, roses, or rice, no pile-up of bridesmaids trying to catch a bouquet. The wedding was much more of a business affair; after all, there was a dowry to collect. The young groom displayed a curious bravado, and the bride hardly showed any emotion at all. It was her mother's show: Like a hawker at a fair or someone charged to get passers-by to come in for a free ten-minute massage, the mother of the bride waved her arms and called for the livestock donations that would comprise her daughter's dowry. Donors would be members of the larger crowd gathered to witness the ceremony, and all attendees came prepared to give. The entire community, in addition to the bride's family, is responsible for helping to fund the dowry, and its magnitude reflects the daughter's value not just to her new family, but to the larger community as well. Tradition dictates that the bride walk from her parents' boma to her groom's family boma, no matter the distance. The walk often begins before sunrise and can take days to complete. Once she is within sight of the wedding guests, she will only take one tiny step per contribution to her dowry: livestock is the only contribution for which she will move forward toward her groom. Once the bride and her groom are united, the officiant begins his brief duties.

Preparing the olboni for his job is as much a ceremony as the union itself. Surrounded by fellow elders, his head is shaved and anointed with ochre by his wife. He dons a magnificent cape made of baboon hide, paillettes of hammered metal, and beads. While his cronies drink beer, which is made by submerging a beehive into a large barrel full of cow urine and then fermented, the olboni is presented with calabashes filled with milk and honey.

The young girl who lost her clitoris did so in the dark confines of a dung hut, and the only signs marking the occasion of her day were the branches being quietly affixed to the outside of the building where she lay. Outside the hut, in contrast to the sobriety of the preparation for the young girl about to get cut, young warriors who hadn't seen each other in a while gathered to jump up and down in a circle and sing songs of their derring-do and sexual conquests. Inside, she endured ritual female circumcision, performed with a rusty, dull knife slicing away what her culture says is the masculine part of her, the part that must be removed so that she can become a woman. This unimaginable act occurred while another woman, who had endured the same violent ritual only a few years before, was tiptoeing toward marriage. While these rites happen across Africa and elsewhere in the world, it is a great testament to the bravery of the Maasai women that more and more are choosing not to undergo the procedure and are encouraging their daughters to stand against tradition.

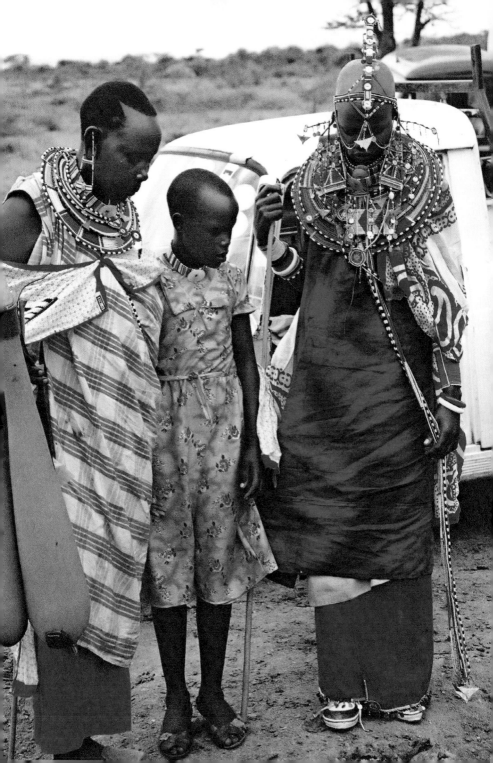

7

ENKIAMA
AND
EMURATARE

(Wedding and Circumcision)

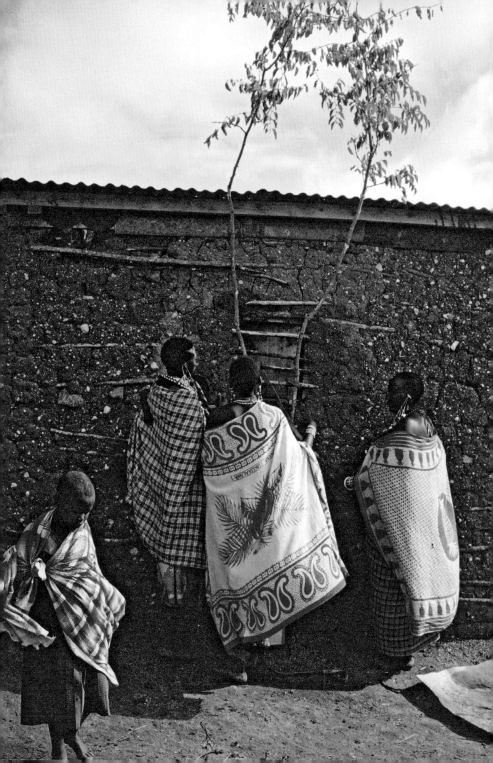

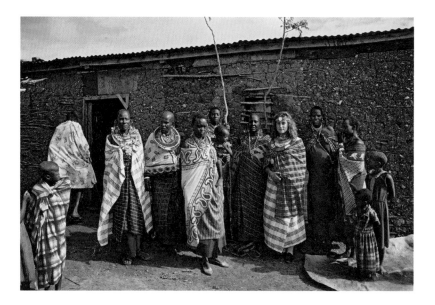

7 MAY 1988
A boma thirty miles from Kimutai's boma

Beautiful beads and shukas everywhere. *Morans* dancing and jumping very high.

A mother playing auctioneer for her daughter's cow and goat dowry, the bride heavily adorned and never looking up, never leaving her husband's house once she gets there. Slowly, slowly, barely moving. I watched the *olboni*, the elder of the ceremony, get consecrated. First shaved, then ochred, then dressed in a cloak of baboon skin and given calabashes of milk and honey. I saw the women tie the branches from a sacred tree onto

Opposite: Maasai women affixing the sacred branches to the
house in which a young girl will undergo her ritual clitoridectomy.
Above: After chasing the author and her camera away with
flailing arms, the mother of the girl undergoing her circumcision
begrudgingly poses for a group photo.
Page 102: The bride's sister and her mother watch her take tiny
steps forward toward her groom.

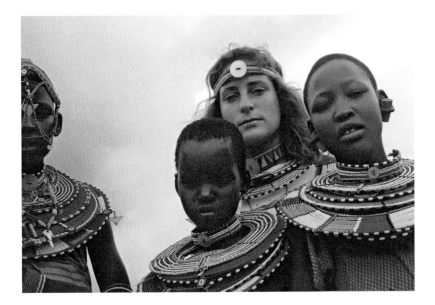

the house of the girl to be circumcised. I watched the *wazee* (elders) sing, and the beautiful girls motion silently. I met mamas, drank chai, tasted Maasai honey beer, and ate meat.

8 MAY 1988
Kimutai's boma

Talked with Sintamei about family planning and the Maasai "tradition" of wifebeating. Dealt with her fears of my potential co-wife status; now I hope we are friends. The sister of John ole Bara, who lives in a nearby boma, gave me a beautiful bracelet on a long walk we took today.

Sankau, Kimutai's third child, cries constantly. If I touch her, she stops. They gave me the name Nashipai. It means "one who brings happiness."

My day-to-day life is more in tune with the movement of the sun across the sky than it ever could be living in a house in California with doors,

Above: After the commotion in front of the boma with their mothers (*see p. 105*), the young girls led the author by the hand to pose for pictures of their own.

windows, and clocks. At home, all the time I spend in my car cuts time itself into smaller, sometimes nonsensical blocks. Living in the boma, we wake when the sun comes up, we all have things to do, and then we seek out ways to pass the rest of the time. Conversations have no urgency, in spite of their urgent topics, as we have hours to while away. There are so few distractions, and time isn't marked by too much. This gives me a lot of time to consider my hosts, my environment, and my feelings about things.

11 MAY 1988
Kimutai's boma

The concept that women ought to be beaten I just can't accept. It's hard to even imagine; the men seem so gentle. It's probably the only way they can feel superior, since the women do all the work. Maybe not. Who knows?

The concept of cleanliness is another outrageous one. Sintamei says "Flies are good because it means there is a lot of milk." Flies in my eyes; flies in the baby Naramal's mouth, ears, and eyes; flies in the milk we drink.

The concept of property is again strange to me. All of my things have been inspected and evaluated and searched.

"I noticed you have some biscuits. I love biscuits. Give me some. Give me medicine."

But are you in pain? Are you sick?

"No."

Then why do you want it?

A woman who had to be in her eighties came into our hut, and for the first time in her life she saw a mirror. She had never seen her own reflection. She asked Sintamei if Kimutai could bring her a mirror.

Sintamei screams like a banshee at the children. She says the Maasai love their children because they don't throw them away like the Kikuyu do.

I don't know why Maasai keep chickens. They don't eat them or their eggs. I will say that the chickens function as a good garbage disposal, though.

Sintamei loves to talk. She doesn't much care for listening. She told me about Maasai birthing. They do it at home, squatting, surrounded by women but facing no one. They talk about me a lot. I wish I understood more.

16 MAY 1988
Kimutai's boma

Maasai live in harmony with nature. I can see how they could look down on other peoples, especially the hunter-gatherers. The Maasai I've met would never kill anything for food that they could not be responsible for replacing with another life. Cows and goats are raised and slaughtered, and nothing goes to waste. The blood, bones, meat, fat, marrow, hides, and organs are used; even some parts of the gut are used for beadwork. They use dead old thorns from the acacia for toothpicks and another, nameless plant's twigs to clean their teeth by peeling its thin bark to reveal a frayable, brush-like center.

I am so sick I don't even know where the energy to write is coming from. My face, head, and body severely ache, and I have a fever. I think I'll try to see a doctor.

17 MAY 1988
Kimutai's boma

Things are really depressing around here. Naserian was bitten by something—we aren't sure what—but her arm has been swollen for three days now. Sintamei has been bleeding for over a week, and Kimutai won't give her money for the doctor, so she's really upset. I feel sick but the real problem is that we are out of water, no rains forecasted. It feels like death. Because I'm sick, I can't drink chai or milk. My head feels like it is going to explode.

The Tanzanians Kimutai hired to do grunt work are being belligerent. One of them is telling the rest of them not to listen to the women, especially the *mzungu* (me). I never ask them for anything anyway. And they're trying to convert Santamo, Kimutai's eldest son, into a "real" Maasai. He hasn't been going to school, disappeared for a few days, and has been wearing dirty shukas. There's something going around, and the children are sick, dirty, covered with flies, and vomiting everywhere. Naserian's husband gave her a black eye. I think I'll stay in bed today and maybe take some codeine.

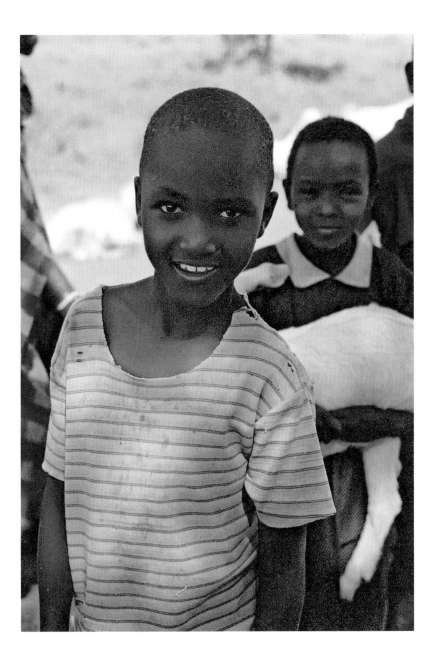

Above: Western clothes make their way to Kenya and across
Africa via many international aid and religious organizations.

I should go to the doctor, but I dread the matatu ride out of here. "At least the Maasai don't smell." That's what Kimutai said. He said the Kambas really smell "here," pointing under his arm. He claims Maasai don't have any body odor. This is supposed to make me feel better about getting into an overcrowded, shock absorber-less car with strangers on top of me and feeling me up and putting their packages on my head while I feel like I am going to die. Kimutai also said that *if* a large pack of Kikuyu just *happened* to kill a Maasai (unlikely, as, by Kimutai's estimate it would take fifty Kukes to kill one Maasai), they would send the Maasai's penis to Japan for medical analysis. He says it's big money.

Another sensorial note: If I never hear another donkey wail, it will be too soon. It's as if they're bellowing for their sorry, ugly lot, but the irony is that their bay makes them all the more hateful and pathetic. Everything cries in Maasailand, except the Maasai, who have their own miscellany of curious noises.

The donkeys wail while the flies buzz a perpetual hum; the goat kids keen while the children vomit. Every night the boys from the next boma come from miles away to watch themselves sing in front of the *mzungu*'s mirror and into my cassette.

Parts of my experience are missing from the journals. I wasn't writing everything down so certain ideas and memories didn't surface until I after I'd left Kimutai's boma. My entries while I was there went from musings to deadpan observations to proclamations; as my mood changed, so did my writing style. Still, I remember broaching difficult and likely unresolvable subjects over and over again, mostly with Sintamei. I was having difficulty accepting a woman's lot in Maasai society, especially the atrocities of physical abuse that I saw or knew to be occurring when I wasn't looking. But Sintamei and Kimutai were my providers, my caregivers. I was in no position to be strident, scolding, or judgmental. On the contrary, the only right attitude to take was to be respectful and gracious. I was living in the small social environment of a boma, but all the while I was very lonely: I

couldn't work out with anyone why certain things bothered me. My voice echoed in my head and on the page.

I was so urgent in my journals: Writing was both essential and isolating for me. The agency of writing at the time was more to record than process. None of the themes are inconsequential subjects, but looking at the journals and knowing myself at twenty-one, the breezy clip of my tone was expedient but belied my inner conflict. I knew I would have to make time to revisit my experiences later, both in my mind and in my writing.

The conditions in the boma were certainly substandard, though I didn't have any real concern for my health or wellbeing at the time. My gauge for "normal" had shifted radically, and I was easygoing and adventurous. It never bothered me that there were no toilet facilities. I found a giant anthill as tall as I was, and it provided great cover for my corporeal processes as long as I was very quick about it. I returned to the exact spot each morning for that daily ritual, and no evidence of my previous visit ever remained. I thought of it as an ant sewage processing plant.

The lack of fresh or clean water, the diet of milk that had been collected in a calabash cleaned by burning the inside with hot embers, and an occasional cooked cabbage dinner resulted in some small health issues for me. I did come to love the smoky, milky tea I drank every day, though. I called it "smoked chai."

8

NAIROBI

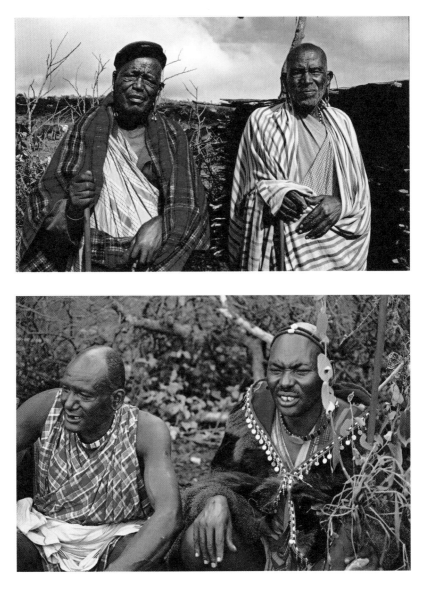

Top: Elder warriors pose in front of an acacia branch corral.
Above: The olboni is ready for his ceremonial duties and
takes a moment with his best friend.
Page 112: Kenya is home to a diverse array of wildlife, and
these elephants roam free in the protected game parks.

Nairobi is a bustling capital filled with opportunity for Africans and foreigners alike. Its name is derived from the Maasai phrase *enkare nairobi*, meaning "cool water," as it lies on the Nairobi River. Nairobi became the capital only after Kenya got its independence in 1963, replacing Machakos, which was the capital during colonial times.

My introduction to East Africa was made near Machakos on the coffee plantation at Katheka-Kai. For all the pastoral peace and quiet and red, fertile earth in Katheka-Kai, there was equal measure of urban noise, threat, and grime in Nairobi. Nairobi is an important city by every measure. It is the home of both the United Nations Environmental Programme (UNEP) and its headquarters for Africa and the Middle East. It houses a securities exchange, a university, thousands of businesses, and myriad hotels. It was an essential hub but not the place where I wanted to be. We students never stayed at the nice hotels or ate at the fancy restaurants—we were broke college kids, after all. When we were in Nairobi, my classmates and I always stayed at a nasty little cheap place called the Iqbal Hotel, with no en suite bathrooms, no hot water, and itchy, dirty blankets. I know for its wealthier inhabitants and expats, Nairobi is the place to be in order to participate in cultural affairs of all sorts. But at the time, I preferred the wide-open plains, the particular blue of the Indian Ocean, the limitless pale blue skies with their flat-bottomed clouds, and the surprise of wildlife that I found everywhere else in Kenya but the capital.

I had also been away from home for a very long time by this point, and I had become even more *hakuna matata* than I had been in California. I was never in a rush to do anything. Me knowing the dates during these weeks was attributable to my journaling more than anything to do with appointments or commitments. I was always surrounded by the Maasai, and by this point, when I would see pale Caucasian babies in Nairobi, I would think how odd it was that their scalps were translucent and that I could see their pulses through their skin.

I was sick with fever and dizzy, and despite my distaste for it, I had to make my way to Nairobi to see a doctor. I was very lucky to find an Indian

physician who would open his office for me, as my visit was on the last days of the Muslim holy month of Ramadan.

18 MAY 1988
Nairobi

I came to Nairobi only to find everything closed: the last two days of Ramadan. Ali at the Iqbal Hotel put his hands between my legs right after he told me I probably have a combination of malaria and something else. I have got to find a doctor and then get out of here, back to the boma. Oh my gosh, it is my mother's birthday and I didn't call.

19 MAY 1988
Nairobi

I ran into one of my friends from school. In his travels, he has noticed that Kenyan prostitutes usually stick their fingers in his ears when they fuck. He says he can't hear what is going on but that he needs more time to decide if he likes it or not.

The doctor I saw says I have a sinus infection and anemia. He says I shouldn't go back to Maasailand, especially since there's no water, and that I can't drink milk. I'm going back tomorrow.

Looking back to that time, my desire to get back to the boma makes perfect sense to me: It was my home. Nairobi was anything but. I was also thinking, as many young people do, that nothing bad could happen to me, despite an environment rife with germs, illness, and bacteria. And I was thinking that the doctor was prejudiced against the Maasai, something I had seen time and time again. I wanted to confront all of these assumptions and challenges with the same devil-may-care, stride-ever-forward bravado that I'd maintained from the beginning of my journey. I wasn't practical—I was mission-driven and had an innate sense of invincibility.

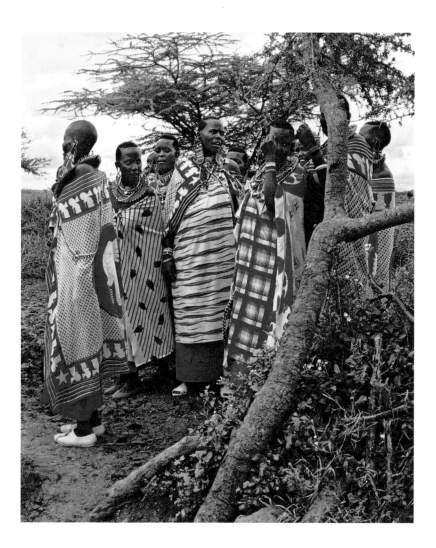

Above: Maasai women await a matatu. The road
conditions coupled with the vehicles' overcrowding
make for an uncomfortable mode of transportation.

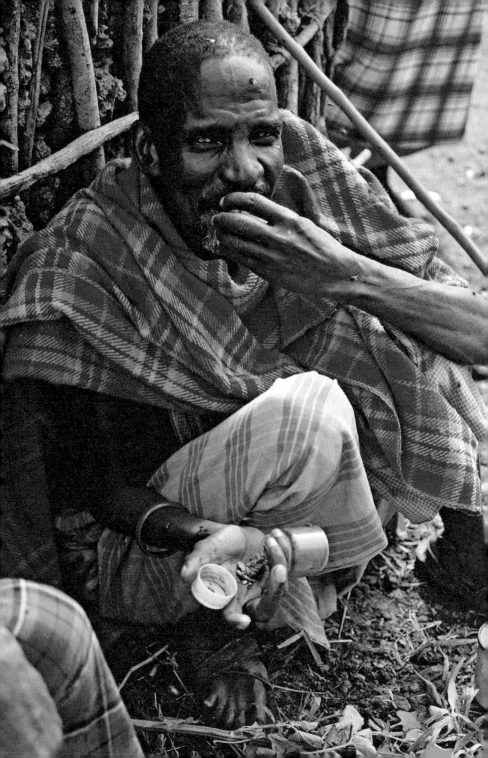

9

CONTRADICTIONS

25 MAY 1988
Kimutai's boma

On the way back here on Friday the 20th, I couldn't find a matatu. I ran into Kimutai's brother-in-law, the chief of Kajiado, and asked him if he was going my way. He said he would be eventually, but we stopped at his boma first. His wife, Inira, asked if I'd like to spend the night. I learned a lot from her. She's a Kikuyu married to a Maasai, which is pretty unusual in my experience. Inira told me gruesome stories about the Kimutai and Sintamei soap opera.

"Who have you slept with?"

"No one."

"Prove it. Spread your legs. Take out that hair. Slut."

Back at the boma, Sintamei is getting delirious. She hasn't eaten in I don't know how long, and it is starting to affect her perceptions. We were going to go to a circumcision today, and she said she didn't want to walk. I told her I'd promised the chief we would meet him at the junction at 9 a.m. and that we should take a matatu. She said, No, let's take the Range Rover. I knew it wouldn't get us there, but she knew that Kimutai had bought me gas so that I could drive it around a bit. I told her there wasn't enough gas. She said, "That's okay. We'll bring Kakuta [Tea's brother], and when we run out, he can go get more."

Right then, the matatu passed by and she told me to ask him for gas. *After* it had passed. Then I explained that, even if we had caught the matatu, the driver needs his gas because he is far from the only place where he can buy more, headed in the opposite direction, and neither of us even knew if he had any to spare. Then she said, "Let's try to drive to 10Q," a small outpost nearby. I said that we don't have enough gas to even go there.

I asked her what time it was because it seemed late. If we were supposed to meet the chief at nine, we would have to leave by eight. When I asked her the time, she said seven. I knew it was after seven, she insisted it wasn't, that Kakuta has a watch. I asked Kakuta. He said it was 8:39. Obviously, we never made it to that circumcision.

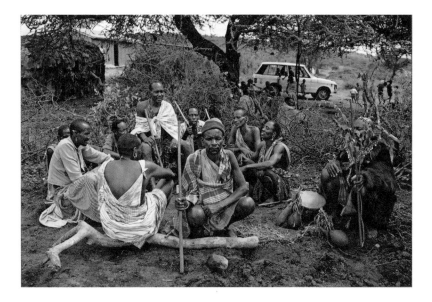

Later that day, I told her that Inira had given me some beads. She immediately said that they were her beads and named some colors Inira didn't have. Then she told me to make a bracelet. I made it, and she said it was too small.

Funny thing: The Maasai do not have a word for the color purple. They don't consider it worth a name. All of the other colors used in their beading have flag-like symbolism: blue for God and sky; green for grasses and for peace; red for bravery, warriorhood, ferocity, and blood; black for rain; white for milk and purity; and yellow for the sun. But purple was only something they saw on morning glories, and therefore it did not warrant either a name or a place in their beading. Orange had no meaning, but the women liked it so they used it.

Above: The elder age-set of warriors gather with the olboni. Kimutai's Land Rover is in the background.
Page 118: Maasai elder offers the author some snuff.

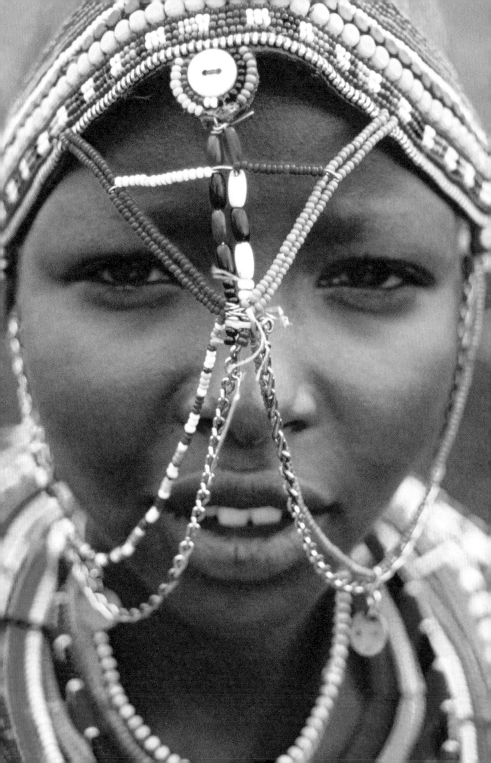

For all of the symbolism imbued into Maasai beading and ritual, the practices and ideals in the day-to-day life of the Maasai I met fell short of ideal. But if I compare how Americans tear up listening to the words of our national anthem or spend a day walking for a cause, and then look at how they often slump back into road rage and racial slurs once the inspirational moment has passed, we can be empathetic to the contradictions within Maasai society. It's easy to rest on a perch of modernity and civilization and judge how others behave, even as we overlook our own ethical breaches or shortcomings. It takes a greater consciousness to examine one's self objectively than it does to judge others. Though we often measure a society by its symbolism, it rarely, if ever, tells the whole story.

While the filth and desperation affects everyone in Maasailand, the incomprehensible wife-beating, female genital mutilation, and marrying off of teenage daughters to old polygamist men for livestock tilts the scales further against women and girls. And no matter the psychological introjection, no matter the moral relativism one summons to rationalize certain actions ("As bad as it is there, in other places they sew her shut! That's even worse!"), the universal truths could not be denied nor could I reconcile them, then or now. But just as anywhere else and with any other difficult topic, resolution does not come easy.

My conversations with Sintamei, Naserian, and Tea had the luxury of timelessness. We lived and worked side-by-side from the earliest moments of the day preparing chai tea to the last moments before we slept, sidelined in the dark while the men enjoyed the warmth and glow of the evening fire. In addition to being second-class citizens (of only two classes), the women were in different places socially, even within the small boma. There was no resentment of this, no rebellion against it. It's simply the way it was.

Opposite: An intimate portrait of Tea.

Since, at first, I was a perceived threat to Sintamei, Naserian's position was firmly on Sintamei's flank. Though that would change eventually, the first female to break rank was Tea. I was less than ten years her senior, unmarried, and a curious guest in her midst. We worked together, milking the cows, looking after the babies and little ones, gathering water, and cleaning the calabashes. We spent a lot of time just looking at each other, trying to communicate. My camera became a way to connect. She let me photograph her with my macro lens, for which I had to have the glass just centimeters from her face in order to attain focus.

The discussions we had about Tea's impending circumcision were just as intimate. Her future was still undetermined: Whom would she marry? Where would she live? How many children would she have? None of those questions would be answered until she had her clitoridectomy and, according to her culture, became a woman. Whatever fear she had about the pain or danger of a circumcision paled in comparison to the idea of living a life without one. When I spoke with the beautiful and hopeful Tea, my gears of introjection shifted. All of the life she saw beyond her childhood, when she was no longer sexless but fully female, was so optimistic. She was pure Maasai, never having left the immediate area of her boma except for the celebrations surrounding weddings, circumcisions, and warrior ceremonies. She did not receive a school education, nor did her mother. High points in her life were punctuated with gatherings of the larger Maasai community, and when it was her day, she would enjoy the anticipation leading up to it and the new chapter that followed.

How I wish now that I had recorded our conversations. We had only affection for each other. In my heart, I was terrified for her and imagined the time when she was the one under the blade. I could only imagine the pain, the blood, the terror. But then I looked at her and saw, in the earnestness of her gaze, that she had no fear. She told me, in effect, "I am not afraid. I want this with all of my heart." And I believed her.

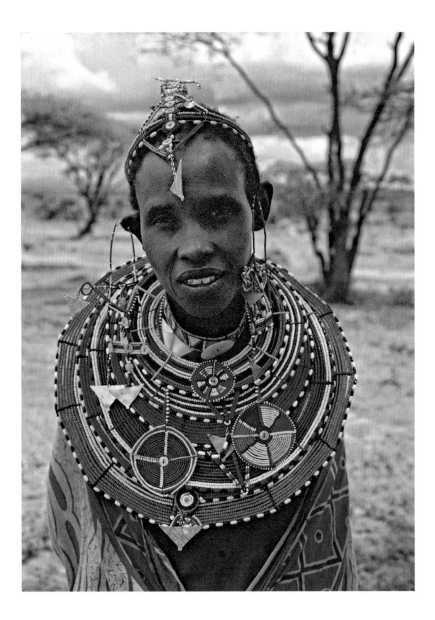

Above: Begrudging portrait of Sintamei on the
author's first day at the boma.
Following pages: Another begrudging group portrait
in front of the hut where the circumcision took place.

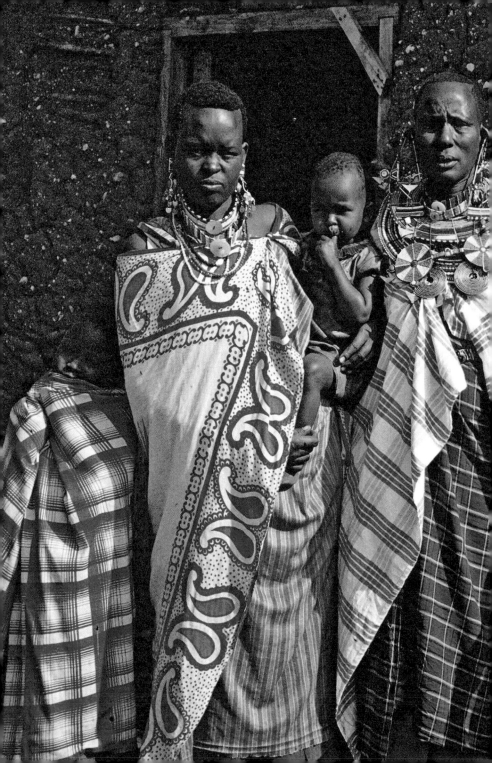

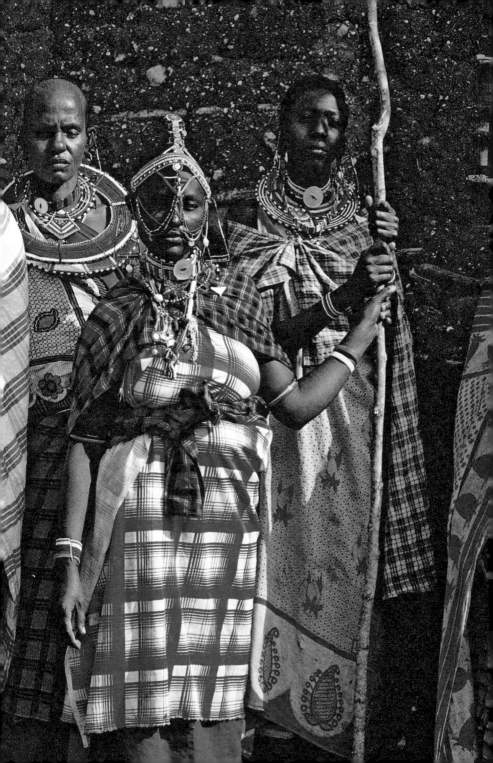

10

KATHEKA-KAI

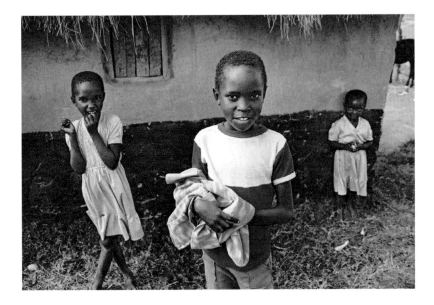

Above: Kamba children in Katheka-Kai.
Page 128: The cook's assistant holds a baby
at the coffee plantation in Katheka-Kai.

At this point in my journey, I left the boma to meet some friends for a safari and a tour of the Ngorongoro Crater. I left all of my shukas and the beadwork I did with Sintamei and Naserian, confident that we would reunite. We promised to meet in a few weeks time in Nairobi so I could say good-bye and collect my things before returning to California.

After the safari, I went back to the coffee-plantation campus at Katheka-Kai, back to the children who received a school education and would encircle me for head touches, back to farmland and families who shared balanced meals, and back to homes with electricity and running water.

In Katheka-Kai with the Kamba people and my American classmates, I was back to speaking English and Swahili and eating regular meals. My writing reflected a more social atmosphere with socialized thoughts and language. These entries are clearly influenced by the fact that I was communicating more fully with other people while I was writing. My English, then in more constant use and with comprehending listeners, takes on a slightly performative quality. My recollections of the boma were fresh but looked different with some distance, with the once-again familiar surroundings of Katheka-Kai and with my classmates to share stories with. And after sharing my experiences in conversation, I would sit down to write. My thinking about Kimutai and the people in that boma had new clarity with a little distance and was illuminated, refracted, and expanded upon in the sunlight of the plantation.

These are journal entries from those days.

3 JUNE 1988
Katheka-Kai

A Kamba laughs at the Maasai predicament. I'm earnestly trying to elicit sympathy for the poor Maasai, who have no water. None to drink, none for the cattle, none with which to wash. The Kamba manages to blurt out, between wheezy laughs, that if the Maasai weren't so dumb and only kept a few heads of healthy cattle instead of scores of unhealthy ones, he might have sympathy for them. As it was, he could do nothing but laugh.

The Maasai, in turn, laugh at the ubiquitous Kenyan belief in magic. The Maasai claim to think it is all nonsense. You see it when they discuss the Kamba *waganga* (witch doctors) hitting the ground with a stick or shaking beans out of a gourd and when they talk about the Swahili burying eggs under the front door stoop of an unrequited love. That last one especially is side-splittingly funny.

Sadly, the Maasai believe that Western remedies have supernatural properties. Whether it is a capsule, tablet, rub, liquid, or spray, they don't care if its medical purpose differs from their own medical needs nor do they heed the recommended protocols or dosages.

4 JUNE 1998
Katheka-Kai

During my stay with the Maasai, I met the old mother of the head of another boma. They estimated her to be in her late eighties. She cannot walk as her leg and hip are deformed, and she is totally blind. The head of the boma asked me if I had any *dawa* (medicine) because his mother remembered when "Lamerika" came to Maasailand and healed many sick people. I said I didn't, but he insisted that even if I didn't, couldn't I pretend? His mother would be so pleased. So I took out my Tiger Balm and went over to the old woman's dung hut, walls crumbling and sadly in need of re-dunging.

I sat with her and massaged her legs, her temples, and her jaws with the balm. She started singing thanks to God and to me: She could see again. The next day she was out there re-dunging her hut.

My Tiger Balm became the boma panacea. Naserian was bitten by a bug and someone slipped the "medicine" out of my duffel and rubbed it on the bite. Sintamei was bleeding (we later determined she was miscarrying), and she rubbed the mentholated, camphor-heavy balm all over her body. Kimutai had a bad cold, and he rubbed it on his big stomach.

My little supply of Tiger Balm quickly ran out. Without asking, they were back in my things and began rubbing all manner of things over their bodies: lip balm, antibiotic cream, shampoo. Obviously, Sintamei's

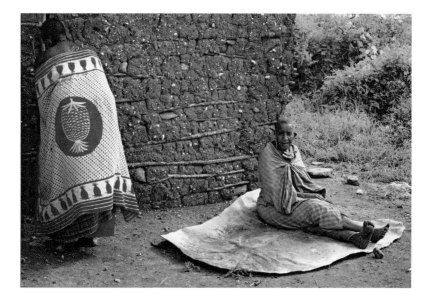

Above: The old woman whose life was changed by Tiger Balm.
Following pages: Kids from neighboring bomas gather around
Kimutai's Range Rover to pose for a picture.

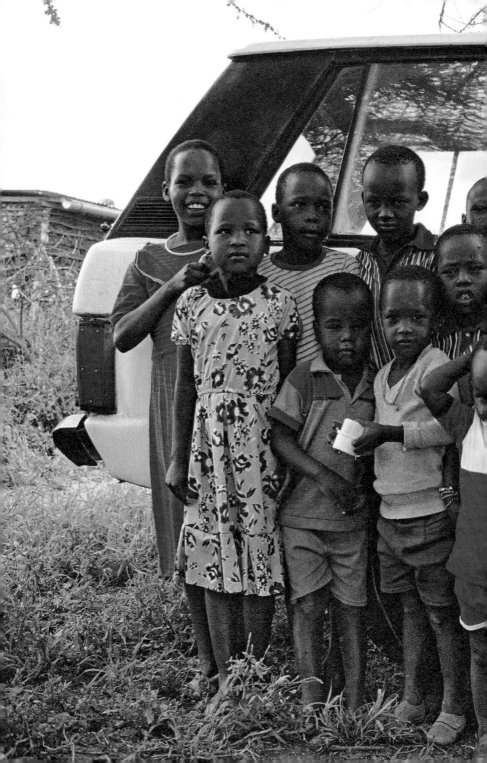

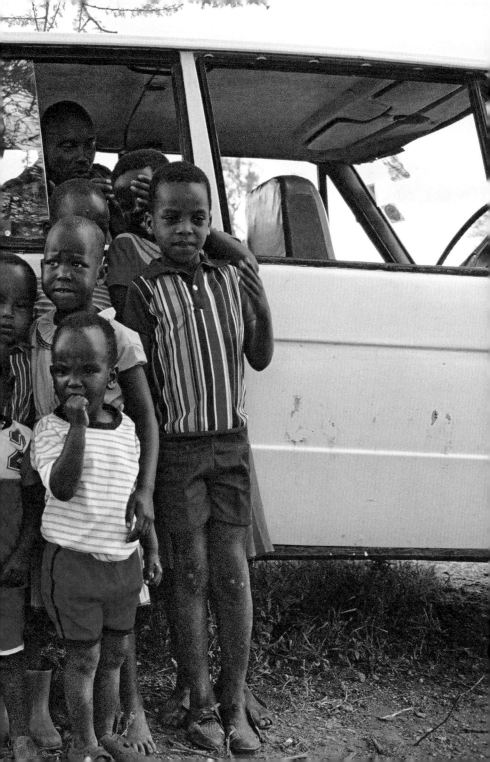

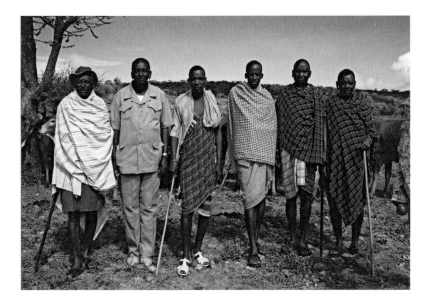

bleeding was not cured by any of these items. I insisted that Kimutai take her to the doctor, and Kimutai insisted that there was no need.

When Kimutai went to Nairobi, women from a neighboring boma quietly sent money for Sintamei to go see a doctor. The doctor prescribed pills for her miscarriage, but rather than following the instructions he had given her, Sintamei immediately distributed the pills to everyone in the boma.

The alternative to this would have been to do what Naserian did after her mystery bug sting got terribly infected, and she went to the doctor. She was supposed to take an antibiotic twice a day for seven days, but in order to keep them for herself, she took them all at once. Soon after taking the pills, she staggered, passed out, and then vomited for several hours. Despite this, the Maasai I knew believed that all medicine is good and good for all problems.

Above: The chief of Kajiado with an elder on his right and members from his warrior age-set to his left.

While Sintamei was bleeding, and Kimutai was gone, she was so weak. One woman milked her cows for her; another cooked for her. The doctor had told her to eat liver, which she did. Another woman brought a piece of leather soaked in fat with two knots tied into it "like eyes, to watch over her."

When the weekend came and with it Kimutai, chaos hit this cooperative colony of women and children. To Kimutai, I said yet again, "Sintamei is bleeding, and she needs to see a doctor!"

"No," he said.

He spent all Saturday and Sunday sitting, snorting his snuff, talking with the warriors who came to see him, and making demands. No one smiled, and people were afraid to laugh. There was a heavy air: Hours lagged, and the only person who seemed to enjoy himself was Kimutai.

5-6 JUNE 1988
Katheka-Kai

The culture of Maasailand represents centuries of absolute male domination. After speaking with the very few Maasai women who could speak Swahili, I found that they tend to praise their own husbands while appraising the terrifying abuses of everyone else's. Women are always being accused of cheating on their husbands and beaten for doing so. In fact, women are beaten for any number of reasons or lack of them. Black eyes and bruised arms are common. For example, while she was still bleeding from her miscarriage, Sintamei had let her hair grow a bit and then had it braided with hair extensions. While he was home for the weekend, Kimutai accused her of cheating, called her a slut, and ripped out her hair. I witnessed this abuse and then witnessed her explaining to everyone else that she had changed her mind and wanted to have her hair short.

A woman must always ask her husband for permission to go anywhere, even to market. A woman is responsible for feeding her children, herself, her husband, and the seemingly endless flow of men from her husband's age-set who arrive uninvited and unannounced and often stay for an extended weekend. These same women, who may not have received

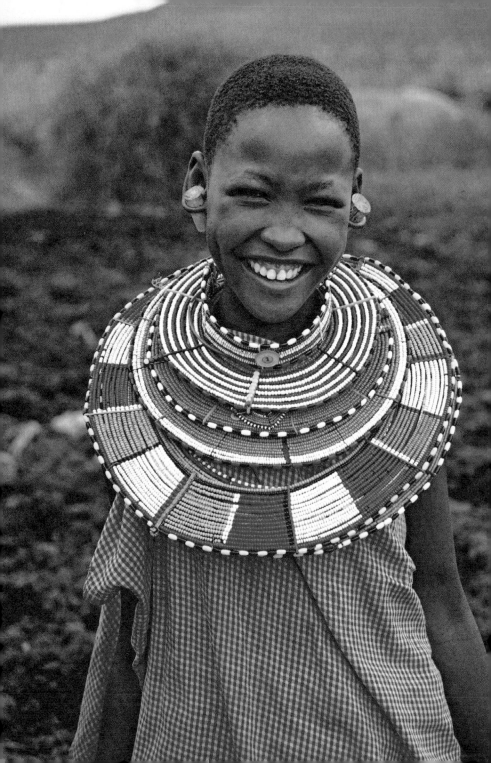

permission to go to market, who may or may not have gotten enough water on her daily trip to its source, will be summarily beaten for failing to prepare properly for guests.

In the evenings when Kimutai is home, all of the women and children are relegated to sitting silently in dark side corners of the huts, waiting to be called upon to bring beer to the men who sit with lanterns and engage in lively conversation. These same women and children feel grateful for their perceived great fortunes, though they never express that gratitude to their benefactors, as they are forbidden from speaking directly to the men. The women heap praise upon their abusers for being superior sexual beings, all the while embracing their tradition of female circumcision. I know that whatever sexual prowess their husbands may possess, without their clitorises, these women are not experiencing pleasure as they could.

Wives and children are status symbols, similar to cattle, and like cattle and the Maasai, it is quantity rather than quality that counts. The livestock and family member chattel come second to the man's needs and priorities and are treated as thoughtlessly as if none were living creatures, let alone human beings.

Kimutai listened intently to my answers regarding how a Western house should be designed and built, presumably because his intention was to build that house and put me into it. However, he turned a deaf ear to my supplications to him to stop beating Sintamei, just as he did to my explanations of the Western remedies I had tucked away in so many Zip-loc bags. It was very difficult to reconcile the idea of my providing status to my host (in the unlikely instance I marry him) with his utter disregard to my fervently held opinions on the sanctity of a violence-free marriage and my layman's understanding of Tiger Balm and Advil.

Opposite: Beautiful young girl with her ear cuts healing around corks. She will have gone through other ritual cuttings around this time, too.

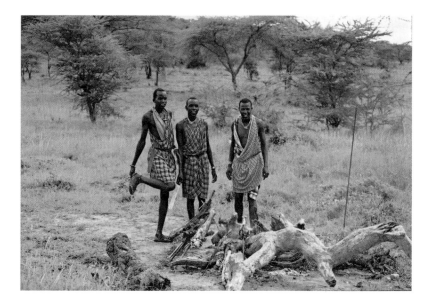

7 JUNE 1988
Katheka-Kai

The ritualistic circumcision is only one aspect of the physical alterations a woman goes through. A woman's beauty is measured by a very different scale in Maasailand than it is in the West, and it has a good deal to do with scarring, cutting, and healing in filthy conditions. Each girl goes through a series of bodily mutilations that begins with her ramming a slim stick through the top cartilage of her ear. Later, she cuts her own right arm and stomach with a number of small incisions to form an arrowhead design. Then she burns a circle into her right thigh, and ultimately she slices her earlobes with a knife, places a rolled up piece of cloth in the wound, and allows it to heal around the cloth to achieve the well known distended earlobe that is so associated with the Maasai aesthetic. She will be judged by these scars, and then she must hope that her family's wealth will allow her to buy enough beads to make the ornamental headbands, armlets, belly jewelry, and earrings that will be the other determining factors in how her people perceive her beauty.

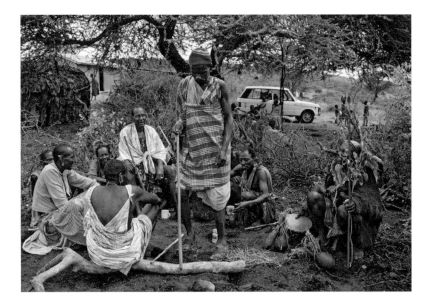

This is all on top of the circumcision and its sexual implications. Let us, for a moment, indulge in the Freudian concept of psychosexual development, or the psychoanalytic sexual drive theory. Though I have an extremely rudimentary understanding of this, I felt I was witnessing something that, at least, seemed to reflect the first three stages.

Breastfeeding is the norm, and as with any other child throughout the world, almost anything goes into the mouth of a teething Maasai toddler. No revelations there. The second, or anal, phase is, again, something universal. During the toilet-training years (albeit this was sans toilet), we see children from ages one to three inevitably fascinated by their own waste. The difference in Maasailand is that, once excreted, the waste is a plaything

Opposite: Warriors roasting a goat over a fire.
Above: Elder warriors gather with their olboni as they await the start of the day's ceremonies.

for the child and any other children who happen to be nearby. Eventually, the three-year-old might seek out a fun receptacle for his or her urine—a cup, a pot, on her food, into the handle of a wheelbarrow—use your imagination! Days are long! And, aside from the real risk of E. coli or any number of other diseases, nothing compares to the dangers that lurk during the phallic phase as described by Freud. Children who are rarely washed play with themselves at all hours and in all situations, causing innumerable infections that are never addressed. And as this child approaches puberty, the requisite rite of passage toward adulthood is executed. The procedure for the boys was described to me by Kimutai:

"We don't do it like the Kikuyu. No, no. All they do is pull the foreskin over the edge and snip it off. That's nothing. We Maasai pull it all the way back toward the body, cut the skin past the point of connection put to us by birth, then we just slice off the top half, you see, so that we can still maintain some of the pleasure." And what of the women? "Oh, they must have all of their pleasure removed."

For the girls, this entails a clitoridectomy often using rusty, dull implements. For both the boys and the girls, circumcisions are not done in a medical setting, so nothing is sterilized and there is no anesthetic. Many, many girls bleed to death or die soon after their surgery from terrifying and painful infections. The Maasai see it as an act of fate, and death is shrugged off as unfortunate but unavoidable. If a girl survives her surgery, she becomes a Maasai woman, ready to be married off. She commits herself to more than her husband when she does this. By marrying one man, she enters a compact in which she must be willing to sleep with any other member of her husband's age-set, with her husband's permission. She cannot refuse this type of request.

Opposite: A pensive moment for a
young warrior in his Western attire.

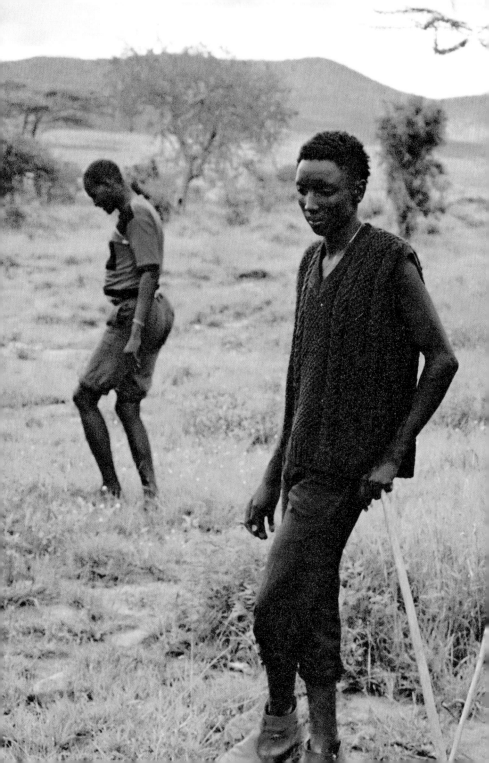

9 JUNE 1988
Katheka-Kai

After living with Kimutai's family for long enough to have my presence become "normal," all pretenses disappeared. One night, when Kimutai was home, I was in bed with Sankau, Kimutai and Sintamei's youngest daughter. We had both fallen asleep, and she slipped between the bed and the wall, leaving only her head visible above the mattress. Her neck was trapped in the crack and she screamed, waking both her parents and me. I pulled her to safety, and her parents, who had jumped out of bed naked, saw that she was okay and went back to bed.

My heart was racing, and though Sankau fell easily back to sleep, I did not. I lay there silently, as did Sintamei, but Kimutai took the opportunity to have sex with his wife, noisily grunting all the while.

The next day, after lunch, Kimutai went into the hut to have a nap and sent one of the children to fetch me. I went inside, and he asked me if he could tell me again about Maasai male circumcision. I told him, No, thanks. He then asked me if I wanted to see. I said no and started to leave, but he stopped me and said that, of course, I had seen him the night before, hadn't I? I told him, no, I hadn't looked. He asked if I was sure that I didn't want to see. I did not respond quickly enough, and he began to lift his shuka, so I turned to leave. He laughed at me and said he knew I was awake while he was having sex with Sintamei, and he knew that I was impressed with his sexual prowess.

I walked away and went to sit in the big metal box of a Range Rover, a safe haven from flies and sex. I sat there until the sun went down because that's when the flies went away, if not the sex.

10 JUNE 1988
Katheka-Kai

Speaking of flies: sometimes the fly populations got so concentrated it made me sick. I stopped swatting them and just wiped them away. I think there is some sort of natural selection at work with the flies here. No one

swats them, they only wipe them away, so the flies are absurdly slow, so much so that one swat takes a handprint's worth of flies with it. When I first got to the boma, it made me sick to watch the flies search for food in the corners of the babies' eyes. I spent days wiping flies from the eyes of whichever child I held. I gave up after a while; no matter how often I wiped, the flies would instantly return.

11 JUNE 1988
Katheka-Kai, final entry

I get so angry when I think about how the Kenyan government is oppressing these people by outlawing their warriorhood, by chasing out Maasai women from the marketplaces, by denying them fresh water and education. A friend in Kajiado told me a story about some Maasai in Tanzania. A local ordinance was passed that stated all men must wear pants in public, a law clearly directed at the Maasai. So the elders of a certain village went and bought one pair of pants for all of the men of the village to wear when they needed them. They hung the pants on a tree on the path that led into town. The male Maasai of this village could only go into town one at a time in pants that fit not a one of them properly. A Maasai associate of the government official who passed this ordinance heard about this humiliation and bullied the official until he lifted the order.

I told this story to Kimutai's family. They loved it.

Following pages: Warriors take the cattle out for a day of grazing on diminishing grasses.

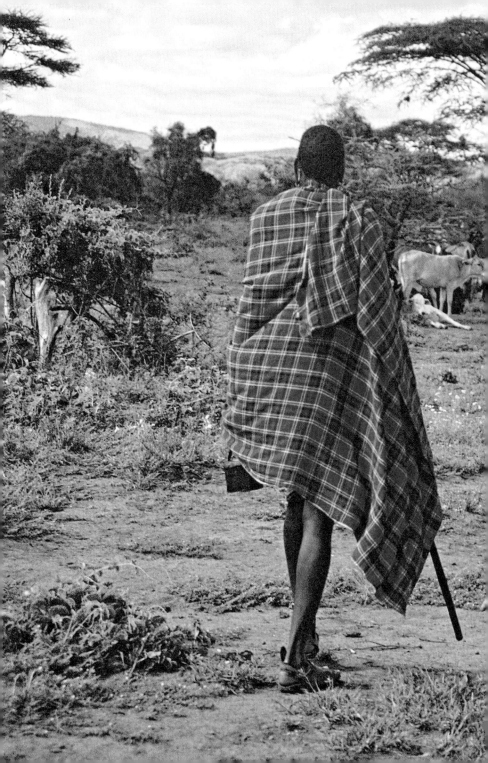

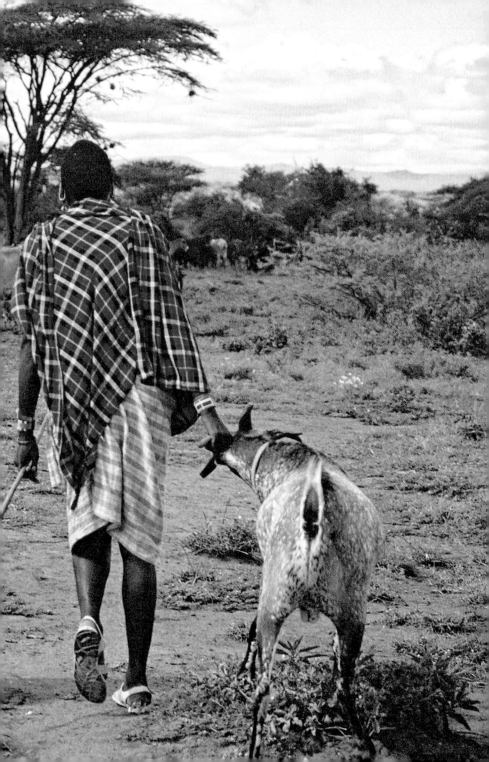

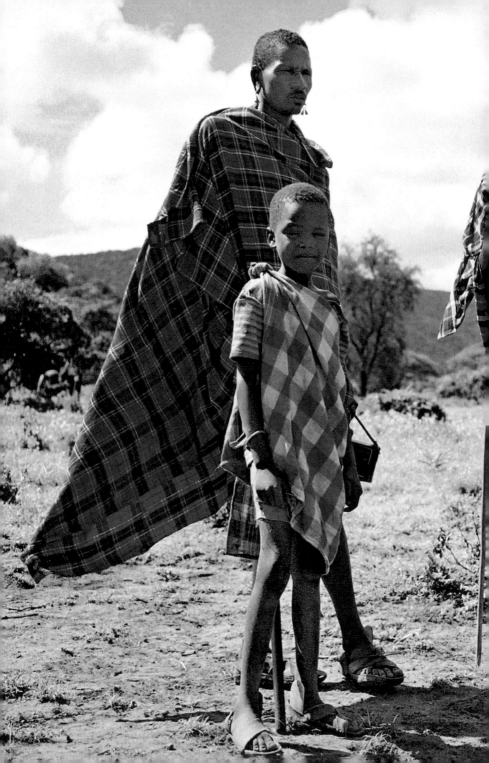

11

THEN AND NOW, HERE AND THERE

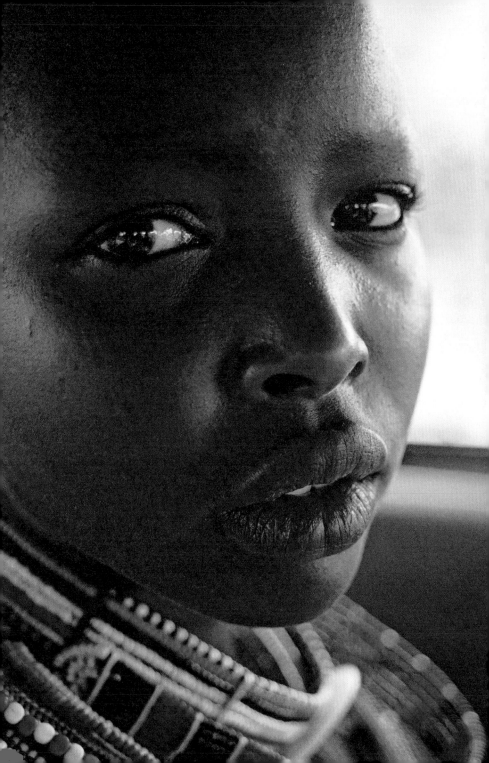

In 1988, N.W.A.'s "Straight Outta Compton" muscled in on the Michael Jackson– and Madonna-dominated airwaves in America. Boutique cocaine crystallized into cheap inner-city crack, and AIDS moved from gay enclaves into suburbia. We saw the end of the Iran-Iraq war and the end of the first two-term Republican president since Eisenhower. Moms had camcorders and minivans, kids had video games and *E.T. the Extra-Terrestrial*. On television, the country saw the rise of talk shows and the fall of the Berlin Wall.

In Kenya during the same time, Bob Marley's voice was heard on every radio, and President Daniel arap Moi passed scandalous voting laws that sent unelected people to parliament. Kenya in 1988 was post-Mau Mau revolution, pre-fundamentalist terrorism. The country received aid from international organizations in the form of food, medicine, and volunteers.

The biggest news story of that year in Kenya, though, was that Jesus Christ himself appeared before six thousand worshippers at the Church of Bethlehem in Nairobi during the famous healer Mary Akatsa's June 11 service. He blessed the crowd in Swahili then invoked an ancient Hebrew curse used to rebuke demons. After twenty minutes, he took leave and accepted a ride from a Mr. Gurnam Singh, who later reported that Jesus asked to be taken to a bus terminal. Jesus exited Mr. Singh's car and then "vanished into thin air," according to Singh's accounts to Nairobi news outlets. It was reported that Mr. Singh never quite recovered from witnessing this miracle.

Kenya doesn't seem as remote to most of us now as it was then. Africa was a romantic idea for much of the twentieth century, inspiring writers, musicians, filmmakers, and fashion designers, and attracting investment, charity, and adventurers. Perhaps the continent seemed more remote because of the mythological notions we hung on its hinges or the inspiration we

Opposite: With Tea in the Range Rover, spending an afternoon talking and avoiding flies.
Page 148: Father and son—Naserian's husband and one of their boys.

took from its many cultures. Maybe part of the reason that it seems less remote now, in the twenty-first century, is that we are finally getting more news out of Africa than we ever did in the past. Much of the news is good, and much of it is painful and disheartening.

I don't know how old Kimutai was in 1988—thirty, thirty-five years old to my twenty-one? Maybe it was not so strange for him to have thoughts of courting me. Why not? Having spent time in Germany as a student, he might have had a good amount of confidence about his ability to relate to women of European descent and had an understandable interest in staying in touch with that time in his life. I certainly feel connected to Kenya after having spent so much time there and learning to speak one of its languages, just as I feel deeply connected to Italy for the same reason.

Like Kenya, Italy holds a lot of romance for Americans: the lovely people, the beautiful language, the food, art, wine, history, and the unforgettable landscapes. But the culture in Italy is easier to slip in and out of, and not nearly as different from ours as is the Maasai culture. We don't hear the languages of Kenya spoken in America that often; we don't find Maasai restaurants, fashion, or, frankly, people, as we make our way through our American streets.

Writing my journals, I did not mean to make the Maasai people I met seem exotic, and in publishing the journals now, I do not want to create a sense of unidimensionality, as this would be false and misleading, nor would I want to foment either cultural fetishism or racial animus. My experience with Kimutai's family was unique. It was for several weeks a quarter-of-a-century ago. The relationships I had and the scenes that I witnessed are snapshots of a place to which I can never return, even if I were to go back and retrace my steps to Mile 46. I know this, and I carry my memories of these people and my time with them with me everyday.

I did try to meet them again, my Maasai family, before I left Kenya. I wanted to say good-bye and to gather the things that they'd offered to hold onto for me while I was in Tanzania and Katheka-Kai. We had a pre-arranged time to meet at a bar near the butcher shop, where I'd first met Kimutai. I went, fully expecting to see everyone: Sintamei, Naserian, and, most of

all, Tea. I waited all day, but they never came. Even Kimutai did not show up.

Seeing Tea was the greatest of my desires and why I waited all day. Tea and I had spent a lot of time together. We had sat for hours in Kimutai's stripped and nearly always fuelless Range Rover, and somehow we'd managed to communicate. My feelings for her were the result of a relationship built in the absence of the words we would have used if we shared a language. We both had to rely on all of our other senses to connect, not the super-powered, super-dominant tool of speech.

Of all of the family, Tea had the most earnest, pure spirit. And because of the connection we had, I knew that her circumcision meant a lot to her, and it was because of her that I felt any conflict about that subject. I know that my personal perspective is formed through a cultural lens, just as hers was. I shrink from making any grandiose cultural proclamations now, just as I respected her beliefs then, because disregarding her personal values became an impossible, inconceivable action. Further, it would have meant also disregarding the values of the family that took me as one of their own, and such a great disrespect I could not fathom.

However, having spent time with Sintamei and knowing the agonies of her marriage—the beatings, the silence, the fear she had of my usurping her position if I became a sister-wife—I do have feelings of anger and near-helplessness about the conditions of life for the women I met and what I imagine must be similar conditions of the many Maasai women I did not. Few things have changed in terms of a girl's safety or experience despite years of Western objections to the practice of female circumcision, arranged marriages, and polygamy. In fact, in 2014 President Uhuru Kenyatta legalized polygamy in Kenya after one government after another simply did not enforce its illegality—a cruel punchline to the joke of generations of inaction. Some reports do show that more girls are refusing circumcision. Though both underage marriage and female genital mutilation is illegal in Kenya, these laws are not enforced, and nothing has changed for women who are beaten. Rape of underage girls is a phenomenon that has only grown in the twenty-seven years since my trip, particularly where radical fundamentalism has taken hold. Since 2003, a primary education

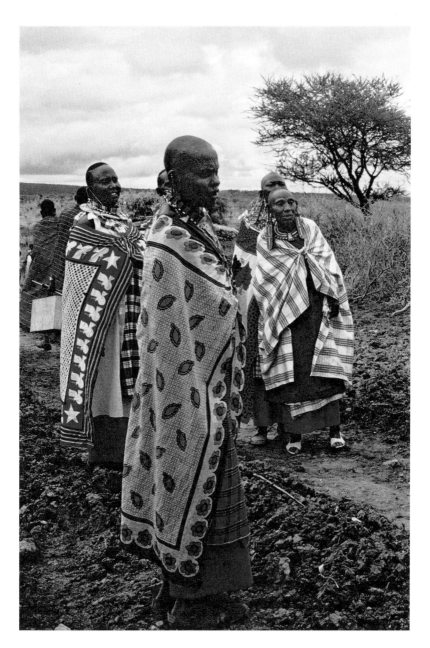

Above: Maasai women, most without access to an
education, rely on each other for guidance and wisdom.

has been free for children of both genders in Kenya, but girls are still often denied education or only receive a limited one because of village traditions or family preferences. This is, perhaps, the most pervasive undercurrent that keeps the status quo of systematic inequity: the people closest to the girls—their friends and family—ensure an imbalance that will negatively influence the girls for the rest of their lives.

Social stratification, particularly dramatic when comparing First World and developing nations, can make cultural education both easier and more difficult. When we rely on volunteers to educate women in Africa about starting small businesses or farming, we are dealing with more concrete subject matter and ideas that do not address abstract concepts like "empowerment" or even "right and wrong." But when people or students, like myself, enter the social arenas and families of rural Africans, we arrive only to stay temporarily, and we bring no palpable or lasting benefit. If we are honest, we are the ones who benefit and whose benefits stay with us for a lifetime.

Women's empowerment conferences have been occurring in Kenya for years, and each year attendees struggle with the slow trickle of change. When Westerners arrive with our own mostly unshakable belief constructs, we are so sure of the truth and value of our cause. We expect our hosts to have the same true north. In reality, they rarely do, so instead we expect the logic of our stance to settle quickly into the established cultures we visit. Westerners have the confidence of our convictions, and we know to our very core that equal rights and liberties are at the very heart of progress and the essence of humanity. But as teachers or influencers, we must also demonstrate respect while we try to guide change and progress, else we fail as leaders paving the pathway to a greater social order—for a civilization to rise to greatness, must it not have an ethos of mutual respect for all?

Any extended period of time away from one's home can forever change a person, even if he or she cannot pin down how, or why. We see that with students who go away to college, with military service people who are stationed abroad, even with friends who move away to another community. There are experiences we travelers have that, upon our return, cannot be shared with the people whose lives have otherwise paralleled our own.

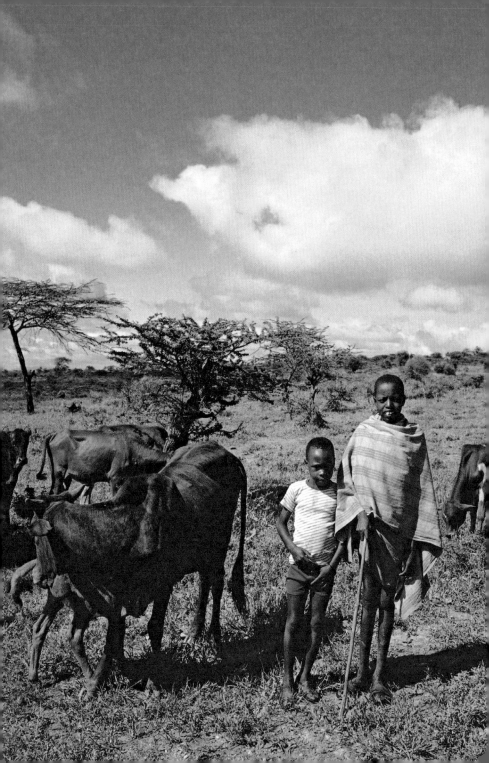

12

RETURNING HOME

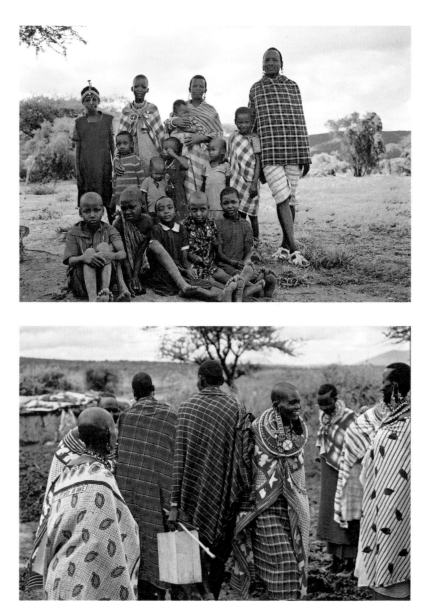

Top: Naserian, her husband, and her children.
Above: Maasai men and women after a day of celebration.
Page 156: Kimutai's young son stands alongside a Tanzanian
boy hired to help graze the family's cattle.

When I returned home to Los Angeles in 1988, I saw giant supermarkets and refrigerators and absurd closets full of clothing options. I was struck by the healthy plumpness of American children's cheeks and the lack of awareness of just how good life is for them. Once, in Nairobi, when I was out with a group of friends after dark, the pavement started to move, and I remember thinking that I might be having hallucinations induced by the anti-malarial medication I was taking. In actuality, the movement was all the limbless lepers crawling out from sewers and body-sized cracks in the pavement and from in between buildings. The most industrious of the afflicted had a type of homemade skateboard to roll on, using turtle-like protrusions where their arms and legs used to be in order to move themselves along the city streets. Then I came back to Los Angeles and had a choice of thirty-one flavors, clearly marked parking spots, and birth control.

While my classmates from Katheka-Kai all went back to their East Coast summers on the Jersey Shore or their families' lake homes, I was the sole West Coaster. I returned to a newly married mother and the impossibly clean conditions of her beautiful home. Returning home to a gaggle of people whose lives had continued on without me in ways that seemed frivolous and indulgent were in contrast to my months of austerity and cultural immersion.

The thought of explaining the life I had just left behind but had not yet fully processed was neither appealing nor simple. All my life I had lived on the same planet as Sintamei, Naserian, and Tea, in the same era, but our rights, choices, options, and opportunities could not have been more different. In my lifetime, I could likely avoid AIDS, joblessness, and hunger. Feminism had suffered attacks stemming from political shifts, tastemakers, and misogynists, but I lived in a place where I still enjoyed many of its achievements, including the right to vote and choose my own husband. The Maasai women did not have any of these things.

Most Westerners are aware of cultural practices that deny girls an education, access to health care, or any expectation of personal safety. Individually, each of us has to determine any action we might take. Too many girls

and women in Kenya and beyond have had lives ruined by fear, poverty, disease, or the possibility of an avoidable and painful death caused by a shaky hand holding a rusty knife. I ask myself: Does cultural deference or ignorance lead people to make assumptions that allow them to look away from realities that are otherwise extremely uncomfortable? Do these assumptions make us apathetic, do they defeat our optimism, or both?

As small or flat as the world may seem, it is actually quite vast and has remote, difficult-to-reach corners. There are many well-meaning charities and religious groups doing very good work on the ground in Kenya and in other parts of the world. Well-intentioned people want to know what they can do to help, but sustained "help" is difficult to achieve and even more difficult to make permanent. Sensitivity to cultural practices must be shown as we export our values around the world, or we could be perceived as indulging in a type of pride that is certainly insensitive, even if the intentions are innocent. Most cultures have a prickly rejection of ethos and practices from other cultures. Maybe all humans wonder—could life be better if I had been born somewhere else? Where is the line where utopia begins? Where is the line that defines unacceptable baseness? Are these lines absolute? With all of the windows into the world we now have thanks to the Internet, will we find answers or only more questions?

Seeking some definition and some roundness to this episode in my life, I have tried to locate Kimutai and his extended family. In fact, there are a surprising number of Maasai on Facebook, but none were people I knew. I have poured through *The Kenya Gazette*, which has a listing of all legal proceedings throughout the country, and looked through death announcements, marriage announcements, and wills intestate. I didn't expect to find anything about the women I knew near Mile 46, but I did find Kimutai. He passed away in the late summer of 2014.

I was not surprised, nor was I upset. I didn't feel much of anything at all. It did remove the possibility of me returning to investigate what had happened to his family. Awful as it was, I couldn't return without his protection or hospitality. An irony and a full stop insofar as a climactic end to my story.

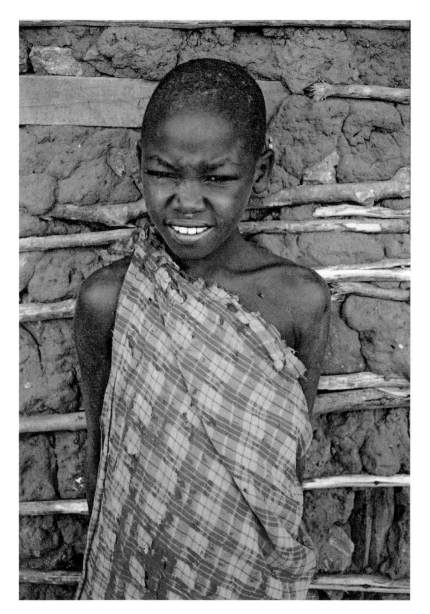

Above: The Maasai diet is limited to milk and cabbage for most days—hardly enough calories to keep bellies full. To stave off hunger, the Maasai chew on sticks and branches, which also serve to keep their teeth clean. The ironic result is that many people in Maasailand are undernourished but have brilliantly white smiles, like this young boy.

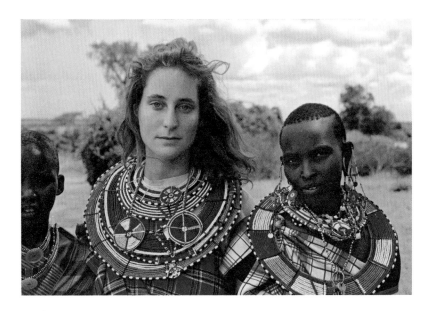

Above: The author and Naserian.

It would have been something wonderful to return to Maasailand. I would love to photograph Tea again, see her children. Tea was a nickname, though, and I never recorded her full, legal name. She is likely lost to me forever.

She and the other women with whom I lived became my family for a while, and once I left, they were family no more. The difficulty of communicating during the late 1980s cannot be understated: Without the Internet, cell phones, or even a mailing address, maintaining a relationship would not have been possible unless I made regular trips back to Kenya, which I did not. It was neither financially nor practically feasible. And so with time, my life returned to its previous patterns and the sounds of Maasailand faded to an indiscernible, though still influential, volume.

Things might have been different. Though I didn't record this in my journals, I had fussed over Naserian's baby, Naramal, quite a bit during my weeks in the boma. At every opportunity, I would take Naramal in my

arms, play with her, and coo. And then, the day before I left the boma forever, Naserian asked me if I would take her baby daughter home with me to America.

This request has ricocheted around in my head for twenty-some odd years. I've thought about her at each milestone of my life. When I graduated from CalArts, she would have been two. When I met my husband, she would have been six and enrolled in the first grade. At our wedding, seven, and when my first child was born, in 1997, she would have been nine years old. I think about Naramal today: She is circumcised, which she would not have been had I adopted her. She is likely married and a mother, perhaps to several children. Had she come with me, she would maybe just be in the early years of a career, perhaps just meeting her life partner. She wouldn't be living in a dung hut, if, in fact, she is living at all. There are so very many hazards in the life of a Maasai.

Naserian must have recognized the possibilities beyond the boma when she offered to give her child to me. It goes against our nature as mothers to do that unless circumstances are dire. The problem wasn't with Naramal; she was angelic in every way. The problem for Naserian, as best as I can guess, was that her way of life and her infant daughter's life were not as good as they could be. She suggested I say that Naramal was mine and take her away with me. Give her a shot at my way of life.

The cause of women and girls is an essential cause at the heart of our very existence. No one, anywhere, should have to suffer at the hand of someone to whom they are bound, whether by marriage or by birth, and the random luck or misfortune of where one is born is not enough of a reason for the suffering endured on much of this earth. Certainly, no child should be subjected to horror by an adult. There is no recovery from a lifetime of inescapable abuse, nor is there an adequate way to describe the eyes of someone whose soul has been snuffed out by repeated assaults. Despite the connectedness of people today, I have no way of knowing the fate of a woman who might have been my daughter, no way of knowing if the light I saw in her eyes when I held her in my arms is now dimmed by defeat.

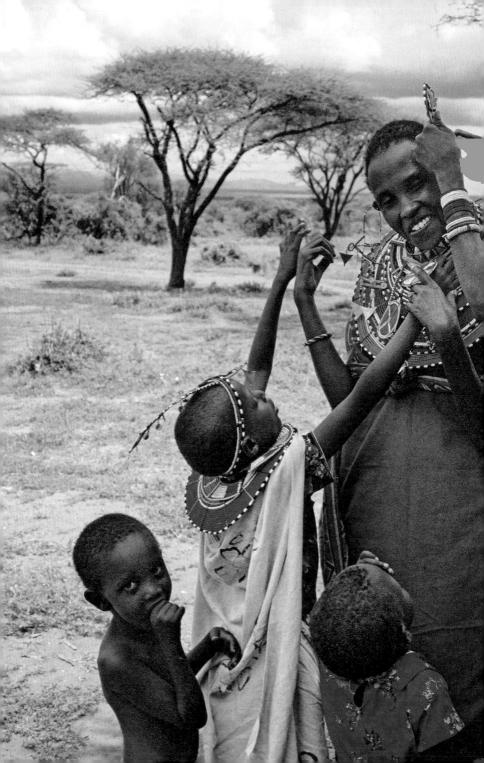

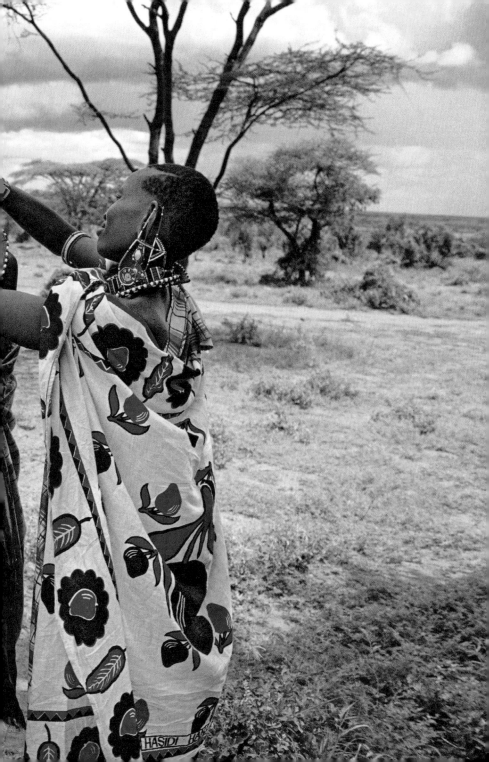

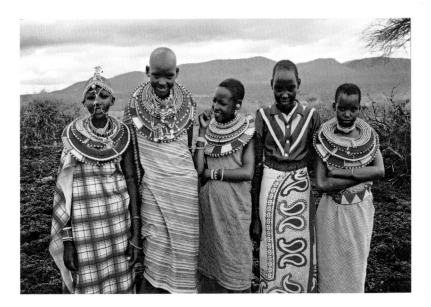

Above: Tea with friends at festivities surrounding an emuratare.
Previous pages: Naserian and the kids help Sintamei primp for a
photo. The colorful jewelry that Maasai women wear today is laden
with symbolism and history. Before the introduction of glass beads into
East Africa by Europeans, jewelry was made by male blacksmiths out
of of iron, brass, and copper melted down from cooking pots or stolen
from railroad construction supplies. By the early 1900s, the heavy
metal bracelets that served both as ornament and as a mode of defense
for women against the blows of their husbands had begun to evolve
into what is now a uniquely feminine form of creative expression.

AFTERWORD

Before I left for Kenya, I met a West African man at a reggae concert in Los Angeles. I told him I was going to be in Kenya for several months. He looked me straight in the eye and said, "You will never be the same again. Africa will change who you are for life." He was right. Being in Kenya and living under Kimutai's protection, such as it was, changed me. Like many travelers or like those who live abroad, my new African equilibrium was immediately upset by returning to a formerly familiar landscape. Coming back to California brought clarity and a new sense of awareness for the need of narrative brevity. Interacting with my family, friends, classmates, and teachers who wanted to know what happened while I was abroad but who quickly lost interest as their own immediate needs intervened taught me a great deal. And talking about Maasailand . . . well, that was a topic too foreign. It needed too much context. How would I begin? My journals took on a different meaning as they became silos into which I could keep elements of my personal experiences separate but accessible, if only for me.

One day, when my daughter was fourteen years old, I showed her my journals. She read them and re-read them, just as I had read and re-read the books on Africa when I was young. My daughter, now sixteen, has just returned from three weeks in Senegal. She is years younger than I was when I went to Kenya, and she went with a cell phone, social media accounts, a completely fulfilled packing list, the buffering of an organized itinerary, and a lot of friends. She came back with stories about where she stayed and about the rice the women cooked at mealtime for the entire village—"in a vat as big as a car!" She told me that one day she lost her sunglasses and told her "uncle" that her eyes were hurting, and he dispatched

all of the village boys to find her glasses—which they did, under a desk at the school where she was helping to teach art. She came home with that particularly painful kind of reverse culture shock one experiences when one comes "home," only to find that most strangers don't smile and greet you like they did during your travels. My convictions about the value of an education that includes cultural exchange were deepened by her experiences, just as I am certain both Kimutai and I are better people for having experienced it ourselves. Both leaders and everyday citizens could have enhanced empathy for the issues facing countless strangers if they had the opportunity to live with those strangers for a time.

All types of cultural exchanges are vital to the health and well-being of people around the world. Without cultural exchange, we cannot understand what values are appropriate to export or how to show respect as we try to help those people whom we believe would benefit from intervention. There are glaring differences between cultures, but our social interactions have universal consistencies. We look at each other's faces when we are in conversation, and we seek meaning from expressions, gestures, and vocal tone.

Travelers gulp down culture. We soak, we slurp, we gorge on it. It's what drives us to spend our money and time on experience rather than objects. Just as we take away something from our experiences, we bring something with us when we travel, too. We bring a face from our home country, an experience to those whom we meet that is inextricable from the nation we call home. And depending on our sense of nationalism and our worldly education, our perspective and our presentation are influenced, and we are often so very certain that our way is the right way.

One summer, we had my dear friends' son from Milan, Italy, stay at our home in California for six weeks. He was only eleven, and it was his first time away from home for any extended period of time. He was a bright and inquisitive boy, and he was so proud to tell us about the Italian origins of so many things: According to him, bubblegum, Coca-Cola, hamburgers, surfing, blue jeans, and all the best cars were invented or designed in Italy. Anything good, anything that he had seen at home, he was convinced was 100 percent Italian.

Often travelers, exchange students, volunteers, business transplants, internationally stationed servicemen and women, and certainly missionaries make the same assumptions as our young houseguest. We think that our way is the best way—after all, how could we be content with our lives if we didn't? This thinking is what drives some of humanity's worst and best actions. It is what gives Boko Haram and ISIS the conviction and motivation to commit terrifyingly violent acts, and it is what drives people to donate to and volunteer for organizations that send books and teachers to schools that are understaffed and underfunded.

My take-away from my months in Kenya has had an enduring and significant impact on the person I have become. My very dimensions were expanded beyond what they would have been had I not gone. I had a new understanding of my small place in this big world and of the breadth of the human experience. I learned how to listen—truly listen—with more openness to what someone is actually saying. There is no true understanding without real listening. And I learned that, while there is no absolute rightful correctness, the lack of its certainty does not mean we should abandon our efforts to approximate it.

My feelings about female genital mutilation may reside between the respectful listening I did with Tea and my own heartfelt cultural convictions, but I never acquiesced to the core ideas and practices of the mistreatment and abuse of women. When I was speaking with Sintamei and Naserian, I began to assert my beliefs on these topics because they were adults, and I was earnest in my desire to discuss, but not judge, their lifestyle. I did not speak this way with Tea because of her age and because of her genuine positive anticipation about her upcoming circumcision. Furthermore, my desire to attend rituals and to live among people who clung to those rites made me consider not only my beliefs, but theirs as well. It would have been terribly hypocritical and disrespectful to criticize a part of their culture I was there to record—not the kind of visitor I would want to be, nor the kind of visitor I'd like to host.

It is easier to be fervent when one is surrounded by those of the same mind. That is partly why war increases the ferocity of soldiers and why

religious worship can make congregants feel more zealous. A high-energy political protest can inspire a casual believer to become a movement leader. Groupthink, *groupfeel*. Transporting oneself to another group and transcending into another reality can shift the earth beneath us and shake the certainty in our beliefs. Add to that the embrace of people, their hospitality, and their warmth, and the shift occurs not just at our feet, but also in our minds and hearts.

Are there absolute definitions of right and wrong? I would guess that most people would say yes. But when one travels the world, those absolutes are rarely defined in the same way. Just as the idea of God changes with geography, so does what defines good parenting, masculine or feminine behaviors, and how to express love. However, I believe there are absolutes, things that live beyond the realm of subjectivity. We must all agree that poverty, violence, and the denial of education and basic liberties result in lives that are nearly unlivable. Willful avoidance of the reality of these conditions by those who do not suffer them is part of the vicious cycle: If we do not see the crimes, we do not contemplate them. Out of sight, out of mind.

When we travel, or visit, or relocate, we are obliged to not simply represent the best of ourselves and our native culture. We must also move consciously through others' homes and territories. We must step back from the certainty of the rightness of our own thinking and beliefs and consider the certainty of our hosts' thinking and beliefs. We are all ambassadors: We represent our cultures, we respect others' cultures, and we honor both the mutuality and the exclusivity of these societies. But we must also be mindful of the essence of humanity and human rights. And if rights are systematically and routinely abused, even if the abuse is isolated, it is our duty as citizens of the earth to object, to interfere, to report, and to rectify.

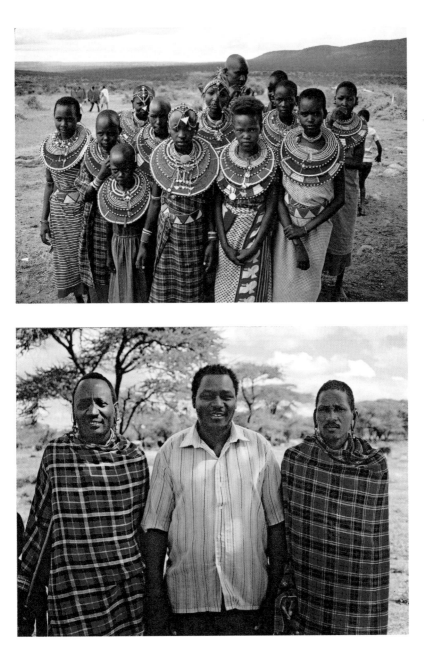

Top: Girls from across the region gather for their friend's emuratare.
Above: Kimutai flanked by his brothers.

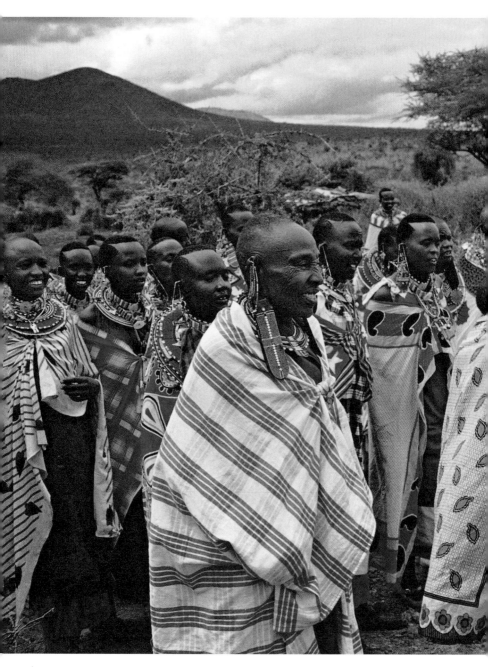

Above: Little girl in a yellow Western party dress facing a sea of Maasai women in traditional red shukas attending a wedding ceremony.

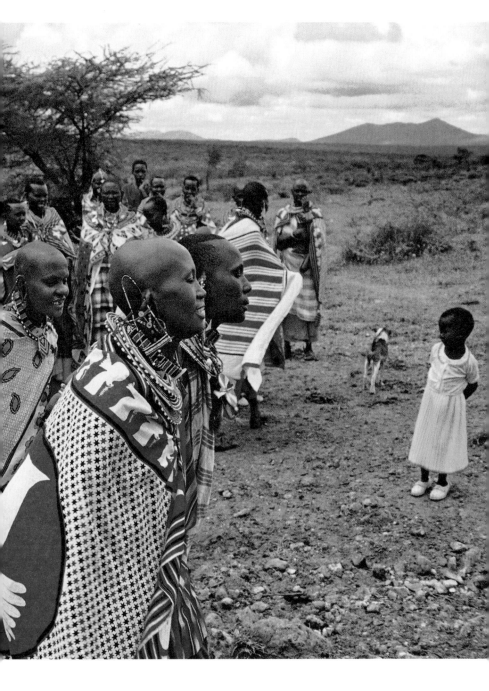

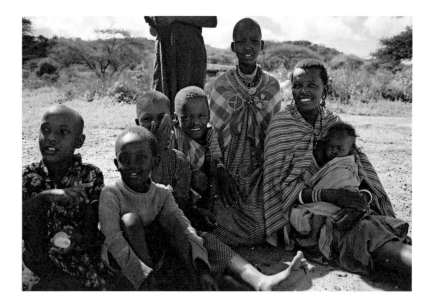

Above: Naserian, Tea, and the baby Kimoret
sitting with other children from the boma.

ACKNOWLEDGMENTS

I am so grateful for my many friends and colleagues, without whom this project might never have come to fruition. My very profound thanks to my editor and sherpa, Courtney Andersson, who took me on the journey from being a woman who writes to an author with a book. To the rest of the folks at Insight, especially Robbie Schmidt and Raoul Goff, thank you for taking a chance on this first-time book author.

I am so very, very grateful to my dear friend Darius Himes. Your vision of this project helped elevate it and me. When you handed me an out-of-print volume of George Rodger's *Village of the Nubas*, you handed me a fresh perspective of what this book could be. Your questions, your beliefs, and your conviction were three of the greatest gifts I have ever received. I'll never be done thanking you.

To my brother Russell Binder, thank you for your easy and effortless belief in this book and for all you did to help me realize it. Thank you to the talented Laura Morton for taking my portrait. Thank you to the few people who read the book in its infancy and who asked me the right questions that helped me understand what it needed to answer: Malissa Feruzzi Shriver, Christine Suppes, David Bowlby, the Honorable Ellen Tauscher, Kate Movius, Donna Roth, Marc and Karen Binder, Gale Kalish, Joe Marich, Ken Kleinberg, Sandy Phillips, and my husband, Robert Shwarts. Thank you to my children for your sustained interest and patience during the writing of this book.

I wish it wasn't too late to thank him, but I am deeply grateful to Allan Sekula, who was my faculty mentor at California Institute of the Arts. Allan was dean of the photography department from 1985 until his death in 2013; his own work combined photography and long texts, a form for which he was well known. From an academic standpoint, he made it possible for me to go to Kenya, and from an artistic standpoint, he helped me form the foundation of this book upon my return to California.

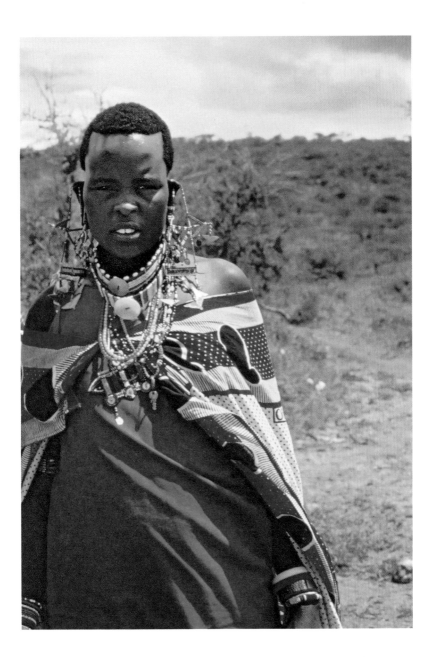

Above: In the spring of 1988, Kenya enjoyed some rains that made the land green and the lives of many Maasai relatively prosperous.

GLOSSARY

BOMA: Also known by the Maa word *kraal*. The Swahili word boma is derived from the Persian *buum*, meaning "garrison, a place where one can dwell in safety." The Oxford English Dictionary ascribes the first use of boma to the writer-adventurer Henry Morton Stanley in his book *Through the Dark Continent* (1878): "From the staked bomas, there rise to my hearing the bleating of young calves." Maasai bomas comprise Maasai houses made from mud, straw, cow dung, and urine arranged in a circle. The boma is surrounded by a fence made from thorny acacia branches for protection from lions.

CALABASH: A hollowed out gourd used to hold and transport liquids.

CLAN: In Maasai culture, a clan is a collection of families who are a sub-section of the larger ethnic group. Bigger than family, boma, or village and smaller than nationality or tribe.

CLITORIDECTOMY: The surgical removal of the clitoris, the nerve and plea-sure center of a woman's genitalia. There is a study on the National Center for Biotechnology Information, U.S. National Library of Medicine web-site called *An Exploration of the Psycho-Sexual Experiences of Women Who Have Undergone Female Genital Cutting: A Case of the Maasai in Kenya*, by T. Esho of the University of Leuven, Belgium. He claims that circumcised Maasai women do not complain of lost libido or enjoyment. In his sample consisting of twenty-eight women and nineteen men between the ages of fifteen and eighty, the Maasai people were interviewed individually and as a part of five focus-group discussions for his report. From the introduction:

Participants responded to open-ended questions, a method deemed appropriate to elicit insider's in-depth information. The study found out that one of the desired effects of FGC (female genital cutting) ritual among the Maasai was to reduce women's sexual desire, embodied as tamed sexuality. This consequence was however not experienced as an impediment to sexual function. The research established that esteeming transformational processes linked with the FGC 'rite of passage' are crucial in shaping a woman's femininity, identity, marriageable status and legitimating sexuality. In turn, these elements are imperative in inculcating and nurturing a positive body-self image and sex appeal and consequently, positive sexual self-actualization. These finding brings [sic] to question the validity of conventional sexuality theory, particularly those that subscribe to bio-physical models as universal bases for understanding the subject of female sexual functioning among women with FGC. Socio-cultural-symbolic nexus and constructions of sexuality should also be considered when investigating psychosexual consequences of FGC.

DAWA: Maa for "medicine"

DHOW: A lateen-sail boat with one or two masts; used in the Indian Ocean

EMURATARE: Maasai circumcision ritual, both for males (foreskin removed) and females (see "clitoridectomy" above). The males prepare for their circumcision for eight days. On the eighth day of preparation, the boy will walk through the camp, past his peers. Some promise that they will kill him or beat him if he flinches while others wish him good luck. When he arrives at the place of his cutting, which he must endure without a blink and without any anesthetic, he changes from his red shuka into a black garment that he will wear for several months while he heals.

ENKANG OO-NKIRI: Maasai "meat ceremony" that occurs after the eunoto. The warriors' mothers prepare a giant feast with the slaughter of a specially chosen bull; it is the first time that the warriors will have eaten with

any women for many years. Men and women fight over the specially pre-pared meat.

ENKANG E-KULE: Maasai "milk ceremony," when the young warriors grad-uate and leave the manyatta. Their now-long hair is ochred and shaved off by their mothers.

ENKARE NAIROBI: Maa for "cool water," from which the city of Nairobi gets its name

ENKIAMA: Maasai wedding

EUNOTO: Ceremony where Maasai boys become senior warriors. Once in the manyatta but before the eunoto, a young Maasai must never eat alone and never in the company of a woman, including his mother.

GIOCOMETTI: Italian-Swiss artist (1901–1966) who worked as a sculptor, painter, draughtsman, and printmaker. Known for his elongated human figures.

THE GLEANERS: An oil painting by Jean-François Millet that depicts three peasant women bent over gathering leftover grain after a harvest. It was completed in 1857 and hangs in the Musee d'Orsay in Paris.

HAKUNA MATATA: As anyone who has seen Disney's *The Lion King* knows, this means something akin to "Don't worry, be happy." It is Swahili for "No worries."

INKAJIJIK: Maa for "house"

INTROJECTION: The psychoanalytical concept of the unconscious adop-tion of the ideas or attitudes of others.

IPA: Response to the Maasai greeting "supa"

JAMBO: Derived from the proper Swahili greeting "Hujambo," this saying is popular for greeting tourists.

KAJIADO: A Kenyan town south of Nairobi that is predominantly Maasai. This was a way station for the author on her way to Kimutai's boma.

KAMBA: An agricultural tribe who live in the Machakos region. The land is herewith referred to as "Kamba Territories"

KATHEKA-KAI: Region near Machakos in the Kamba Territories

KISWAHILI: The national language of Kenya, along with English. It is a language that has its roots in Arabic and Bantu. In English, we use "Swahili" for both the people and the language.

LAMU: An island in the Indian Ocean, home to the Swahili people

LLOIMON: Maasai news carriers

LOALGUANANI LEAKASHE: One of three leaders selected from a Maasai warrior age-set, the boy who is honored with a specially selected cow during the eunoto

MAA: The language of the Maasai

MAASAI: "The speakers of Maa," as well as "my people"

MAASAI MARA: The Maasai Mara National Reserve is a protected area for game contiguous with the Serengeti Reserve in Kenya's Mara region

MAASAILAND: The geographic areas that are Maasai tribal lands. There is likewise a Kambaland, Turkanaland, etc.

MACHAKOS: Located in the Kamba Territories, the capital of Kenya during colonial times and the former location of the campus of Friends World College

MALINDI: A coastal tourist town north of Mombasa

MANYATTA: A Maasai boma designated by a spiritual leader for housing a warrior age-set for approximately ten years. Also known as *emanyatta*.

MATATU: A small, enclosed truck used for ridesharing throughout Kenya

MEISHOO IYIOOK ENKAI INKISH O-NKERA: Maasai prayer—"May the Creator give us cattle and children."

MILLET: A painter from the Barbizon School (1814–1875).

MOMBASA: The second largest city in Kenya. Also a major port, and cultural and tourist center.

MORAN: Maa for "warrior." Warriors are responsible for the protection of the Maasai and their cattle from livestock raids, lions, and other intrusions.

MZEE: Swahili (and general usage) form of polite address and word for "an older man" (plural *wazee*)

MZUNGU: Kiswahili for "non-African," usually Caucasian

NAIROBI: The capital of Kenya

NASHIPAI: Maasai name for "one who brings happiness." This was the author's Maasai name as given by her family.

NGONG: A Kenyan town southwest of Nairobi along the Great Rift Valley. "Ngong" is the Maasai word for "knuckles," which the four ridges that stand out among the plains resemble.

NGORONGORO CRATER: The crater within the Ngorogoro Conservation Area, a UNESCO World Heritage Site in Tanzania

OLE: A part of a Maasai name that designates to which family one belongs.

OLBONI: A Maasai spiritual leader and prophet. The olboni is one of the most misunderstood members of the Maasai. They all descend from one clan and are the spiritual leaders of the Maasai, but the success of so many Christian missionaries and Islamic leaders has led many non-Maasai to believe that the olboni are devil-worshippers.

OLOBORU ENKEENE: One of three leaders chosen from the Maasai warrior age-set, the boy who receives a leather strap with a knot tied into it. The knot is untied at the end of the warriors' time in the manyatta to symbolize the warriors' release from their isolation.

OLOTUNO: One of three leaders selected from a warrior age-set, the boy who must bear all of the responsibility for every good and bad deed of his age-set.

ORNGESHERR: A ceremony that marks when a warrior can start his own homestead.

ORPORROR: Also known as "age-set." The group with which boys will elevate through Maasai society into warriorhood and eldership, composed of similarly aged boys from the same clan. Age-sets are determined at about every fifteen years, and within each are two subsets, so that movement of warrior "classes" are about seven years apart.

SAFARI: Kiswahili word for "journey."

SHUKA: The large, rectangular cotton fabric that always features the color red and is the daily attire of traditional Maasai

SIDAI OLENG: Maa for "Thank you very much"

SPRING WARRIORS: The Maasai, so called because of the bounce in their gait

SUPA: Maa for "hello" or "greetings"

WAGANGA: Swahili for "physicians," but often used to designate so-called witch doctors. (singular *mganga*)

WAZEE: Swahili for "elders." (singular *mzee*)

WIFE INHERITANCE: Widows are "inherited" by male relatives of their deceased husband, often with the requirement of having sex with a man of low social standing to "cleanse" them of their dead husband's "evil spirits."

Opposite: To calm the cattle, the men of Kimutai's boma
would stroke the skin surrounding the animal's tail.

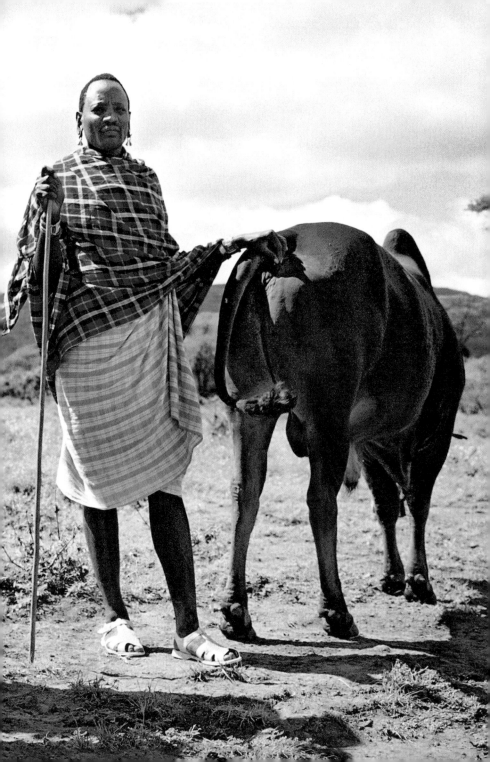

Above: Maasai honey beer, topped with the detritus of dead
bees and honeycomb and the remains of the hive that broke
apart when it was submerged into the fermenting cow urine.

MAASAI CULTURE AND HISTORY

MAASAI TRADITIONS

In addition to the traditions outlined earlier in this book, there are others that may shed more light on the beliefs and behaviors of the Maasai. For instance, traditionally, a woman cannot refuse to sleep with any man from her husband's age-set, but she is ostracized if she ever sleeps with a warrior from a younger age-set. In order to test their wives' fidelity, warriors conduct a bull skin ritual during the engkang oo-nkiri (meat ceremony) that comes after the eunoto ceremony, wherein the skin of the bull slaughtered for the feast is placed somewhere in camp. Older warriors wrestle around the skin to try to reach it, and, according to traditional beliefs, whoever reaches the hide first has the proof that reveals his wife's infidelity. The winner and his peers will spurn the woman, and, in order to be forgiven, the woman returns to her father's boma to retrieve a cow. She presents the cow to her husband, and custom dictates that he must forgive her, though he is likely to give the cow to another man.

There is a lot of competition between various age-sets—and not always the healthy kind. The prolonged bachelorhood of the younger morans, who can easily observe their polygamous elders, along with the hunger and isolation they experience, likely contribute to the problem.

After the manyatta years, the day comes that marks a boy's entry into his senior warriorhood, and he goes through his eunoto, which is more like a festival than a ceremony. The eunoto takes place at another specially selected location, one with exactly forty-nine houses. In the forty-ninth house, the olboni, a spiritual leader and prophet, expects to be entertained by stories told by the young male residents of the encampment. The boys gather around a fire into which an animal horn is placed, and one of the boys must assume the curse of misfortune that comes with retrieving the horn before it is burnt to ash. If no one pulls out the burning horn, the entire age-set will be cursed.

Once the warriors leave their eunoto, they are released from their communal life into their independent ones, and they begin to contemplate marriage. The final part of the years-long initiation into warriorhood is called orngesherr, and it signifies the junior elder-level of status when a warrior can start his own homestead. Up until this time, he is still living in the homestead of his father, although he may have multiple wives and children.

MAASAI CULTURAL HISTORY

The Maasai believe that cattle, specifically, and livestock, in general, are their divine providence. So much of their religious practice, daily life, and economy are based on these animals. Maasai are ever mindful of not overgrazing lands but also believe that it is against God to deny cattle and man access to water and healthy land. The Maasai were nomadic or semi-nomadic for thousands of years, and today they adhere to a communal land management system that allows for movement of herds to support the interests of all families in a geographical region. Maasai have historically traded livestock and livestock products with each other and have increasingly traded with outside peoples for beads, cloth, and even grains and produce.

During my stay in Kenya, the arap Moi government was actively trying to outlaw warriorhood. It was largely an ethnically motivated effort. Earlier in the 1960s, when Kenya attained independence from the colonial British, and again in the 1980s, many lawmakers from agricultural tribes enacted policies that disrupted the traditional Maasai way of life. For instance, starting in 1963, a ranch system of land ownership was placed on non-arid lands in Kenya that were best used for grazing cattle, the practice the Maasai were most expert at. The idea of private ownership was not a traditional Maasai concept, so when the individual and group ranch system was implemented, an entire facet of how Maasai interacted with and saw each other changed. While some Maasai got individual ranches, many became a part of group ranches, tying the Maasai's relative wealth to where their ranch was on the plains. The distribution was inherently uneven and unfair, as some families had their own land and some families had to share. In many cases, poverty became an issue because herd sizes had been decimated by diminished grazing opportunities for Maasai livestock.

MAASAI GEOGRAPHICAL HISTORY

The Maasai trace their roots back thousands of years. Some Maasai, like my host, believe that they are one of the lost tribes of Israel. In fact, the Maasai descended down the Nile into the Rift Valley, where they have been for generations. Most Maasai live in Kenya, though there is a Maasai population in Tanzania.

MAASAI POLITICAL HISTORY

The Maasai were a sovereign nation when the British arrived in Kenya and were treated as such by the British government by virtue of the treaties of 1904 and 1911—something not legal nor pursued with tribes. At the time of the British arrival, the Maasai territory spanned 700 miles north to south and 400 miles east to west; colonists considered the Maasai land its own country. By 1913, the British courts deemed the Maasai a tribe and not a sovereign nation, thereby annulling earlier treaties and causing a great dispossession of Maasai lands and rights.

In post-independence Kenya (1961–1963 through today), the new African-run government embraced policies of assimilation and integration, hoping for a unified country that reformers had promised would bring Kenya toward economic and social stability. The treaties of 1904 and 1911 had stipulated that, upon independence, the Maasai would regain six million hectares of land that had been taken, along with their sovereignty, but the new government did not abide by those treaties.

Without zealous representation in the parliament, Maasai lands are today being exploited for tourism, military bases, energy sites, and political gifts, according to reports.

RECOMMENDED READING

There are some wonderful writers whose work I have enjoyed immensely: Lily King in her 2014 Kirkus Prize–winning book, *Euphoria*, depicts a love triangle between three anthropologists in New Guinea in 1933 that is loosely based on the biography of Margaret Mead. King is a magnificent storyteller and her American female protagonist studying the sexual habits and mores of an indigenous people makes for a great read.

Abraham Verghese's *Cutting for Stone* (2010) is an incredible piece of fiction from this Stanford professor/doctor/writer whose previous writing was nonfiction. This book spans decades and the globe but focuses a great deal on Ethiopia. For me, it was one of the most fascinating, memorable books from the last ten years.

Barbara Kingsolver's *Poisonwood Bible* (2000) is an oldie but a goodie. It tells the sweeping story of an evangelical Baptist missionary who brings his family to the Congo in order to convert natives to Christianity.

There are some marvelous novels coming out of Africa today, and a wonderful place to start is with Chimamanga Ngozi Adichie's *Americanah* (2014). Adichie is an award-winning Nigerian writer, and her work is beautiful and compelling.

Angela Fisher's *Africa Adorned* (1984) is a classic that is both a coffee-table book and an academic study of the various attire, scarification, jewelry, and body stylings across the African continent.

Karen Blixen's *Out of Africa* (1937) is a memoir of the writer's seventeen years in Kenya from 1914 to1931. These dates are important because the book reveals colonialist and racist attitudes that were prevalent at the time. Blixen's poetic language and her love of the country only partially mask what many readers may find offensive in her attitudes, but the book still reveals a Western female perspective during a time when we will not find many other examples.

The other best example, though, is Beryl Markham's *West with the Night* (1936). The writer grew up in Kenya and knew Blor and Karen Blixen, Ernest Hemingway, and Denys Finch-Hatton. Markham was known for setting an aviation record for the first east-to-west solo flight across the Atlantic and was a bush pilot in Kenya. Her writing was really quite marvelous.

I would be remiss if I did not recommend reading *What Is the What* (2007) by Dave Eggers. It is a fictionalized autobiography of a real-life Sudanese lost boy named Valentino Achak Deng.

Lastly, for books that are in the same photographic literature genre as *Mile 46*, George Rodger's *Village of the Nubas* (1955) is a treasure, as is Allan Sekula's *Fish Story* (1995). These two may be hard to find but are well worth the search.

ABOUT THE AUTHOR

Joni Binder received a BFA in photography from California Institute of the Arts, where she now serves as a trustee. She also served as a trustee at the San Francisco Museum of Modern Art and as the president of the museum's Modern Art Council. Joni has provided leadership as an arts education advocate in California, serving as one of the subcommittee chairs for the CREATE-CA Task Force, and nationally as a Fine Arts Committee member and Education Committee co-chair for the Diplomatic Reception Rooms of the U.S. Department of State. She serves on the Leadership Circle for Futures Without Violence and is currently helping lead a campaign in partnership with The Representation Project in an effort to raise awareness about healthy masculinity and its role in eliminating domestic violence, particularly in professional sports.

To learn more about Joni Binder's photography, to read her blog, and to find out where she will be speaking next, please visit her website.

Share your own travel stories and thoughts about the book on social media—just go to the website below and click on the Facebook or Twitter icons. We would love to hear from you!

www.jonibinder.com
Twitter @joni_california
www.Facebook.com/JoniBinder.Author

EARTH AWARE
E D I T I O N S

PO Box 3088
San Rafael, CA 94912
www.mandalaeartheditions.com

Find us on Facebook:
www.facebook.com/MandalaEarthEditions

Follow us on Twitter: @MandalaEarthEditions

Published by Insight Editions, San Rafael, California, in 2016. No part of this book may be reproduced in any form without written permission from the publisher.

Library of Congress Cataloging-in-Publication Data available.

ISBN: 978-1-60887-752-2

PUBLISHER: Raoul Goff
CO-PUBLISHER: Michael Madden
ACQUISITIONS MANAGER: Robbie Schmidt
ART DIRECTOR: Chrissy Kwasnik
DESIGNER: Malea Clark-Nicholson
EXECUTIVE EDITOR: Vanessa Lopez
PROJECT EDITOR: Courtney Andersson
PRODUCTION EDITOR: Rachel Anderson
PRODUCTION MANAGER: Blake Mitchell

ROOTS of PEACE REPLANTED PAPER

Insight Editions, in association with Roots of Peace, will plant two trees for each tree used in the manufacturing of this book. Roots of Peace is an internationally renowned humanitarian organization dedicated to eradicating land mines worldwide and converting war-torn lands into productive farms and wildlife habitats. Roots of Peace will plant two million fruit and nut trees in Afghanistan and provide farmers there with the skills and support necessary for sustainable land use.

Manufactured in China by Insight Editions

10 9 8 7 6 5 4 3 2 1

Text copyright © 2016 Joni Binder
Foreword copyright © 2016 Darius Himes
Photographs copyright © 2016 Joni Binder

The author used several online resources—particularly the wonderful www.maasai-association.org—to research aspects of Maasai culture she did not personally encounter. She also found helpful information at www.everyculture.com, www.culturalsurvival.org, The National Center for Biotechnology Information's website www.ncbi.nlm.nih.gov, and the Foundation for Sustainable Development's website www.fsdinternational.org.

When the author was invited to spend time with Kimutai and his family, she went with the explicit understanding that she would be photographing them. Everyone she photographed gave their consent, either directly to her or through Kimutai. As many of the Maasai she met were unable to provide written consent, all consent to be photographed was verbal. In order to protect her subjects' privacy, all names of the Maasai she met have been changed.

Cover Photo © Joni Binder
Author Photo © Frederic Aranda

Page 4: A young Maasai girl dons her beaded jewelry for this portrait. The cuts she recently endured across her earlobes, which prepare her ears for the traditional Maasai earrings, are healing.

Page 8: If this photo was a clock, Tea would be at almost 11 o'clock, Santamo would be at 11, and Naserian is the center of the clock. These are some of the faces of Kimutai's boma.